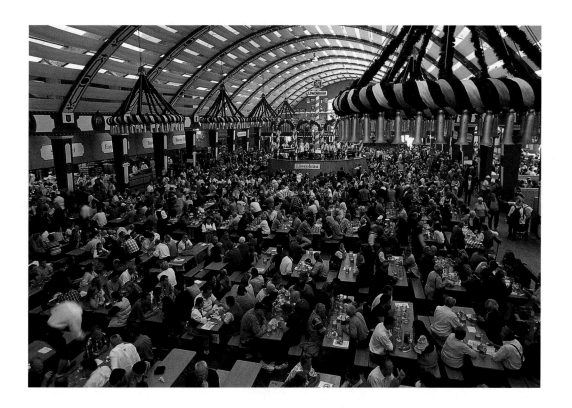

Journey through

MUNICH

Photos by

Martin Siepmann

Text by

Christine Metzger

Stürtz

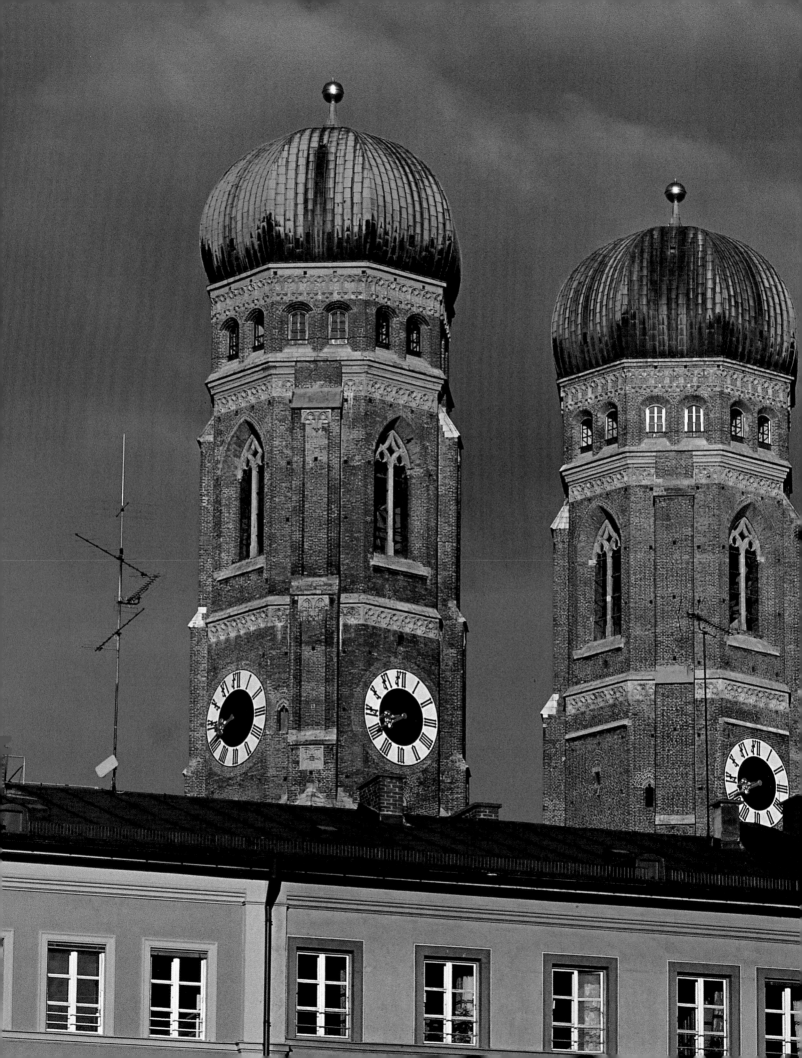

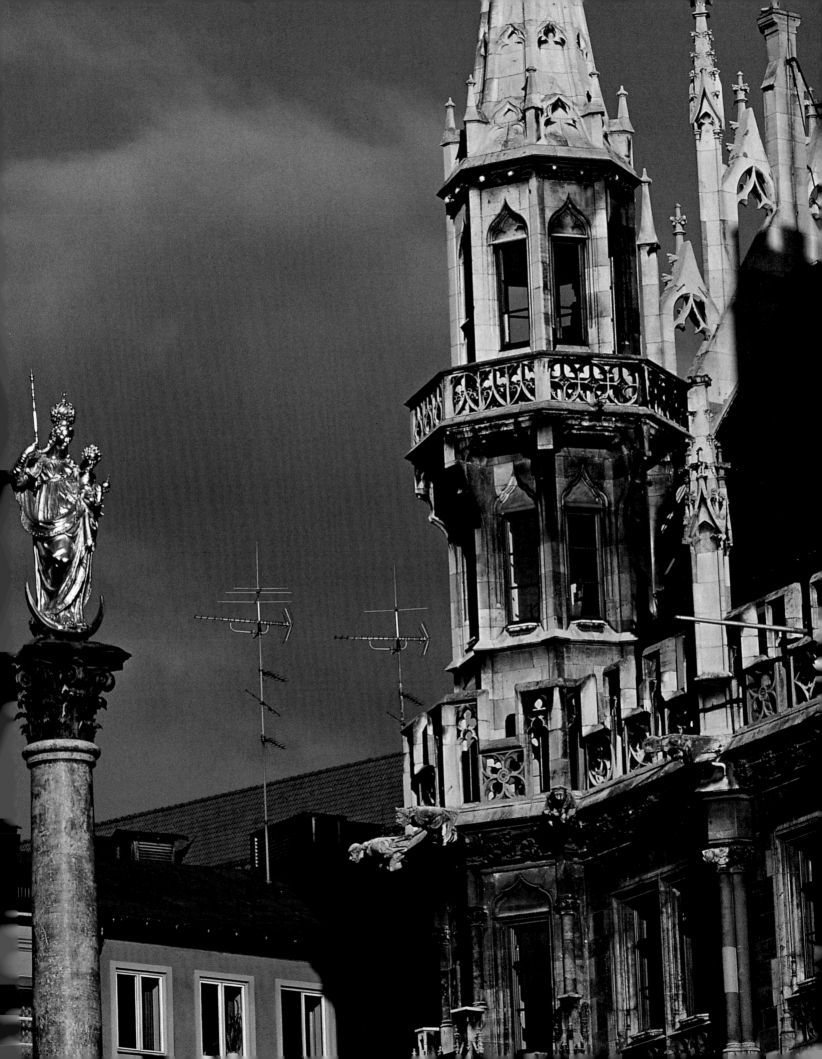

CONTENTS

First page:
Squashed up close like sardines in a tin, there's just enough room for the punters at the Oktoberfest to raise their glasses to raucous prompts of »Prosit!« from the band – as if these were needed…

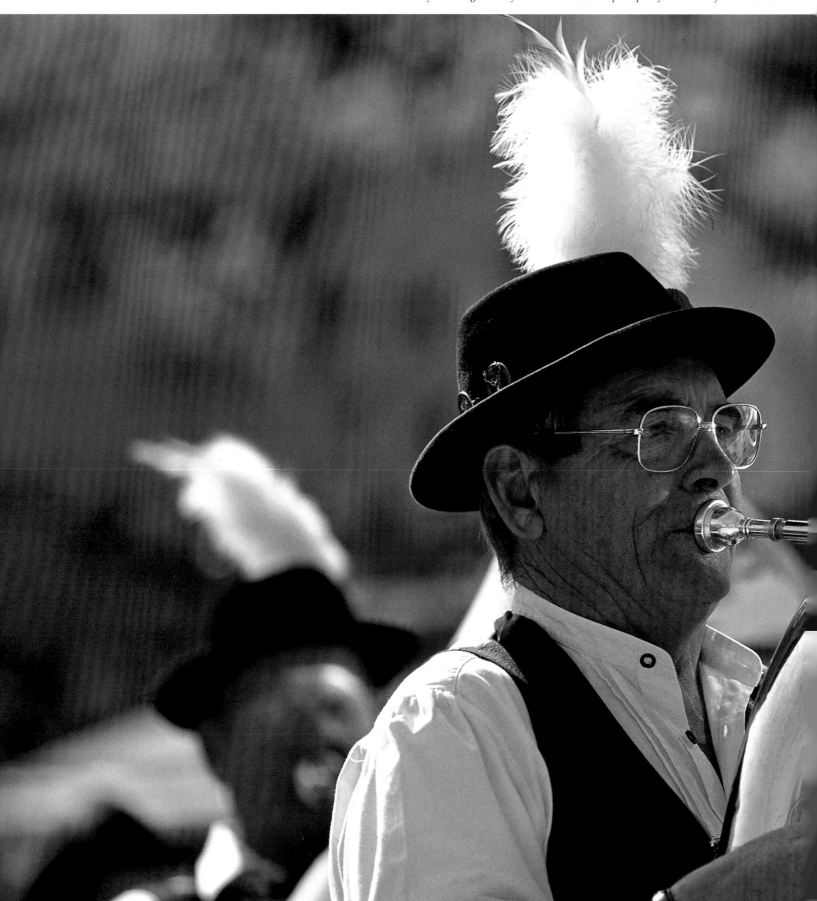

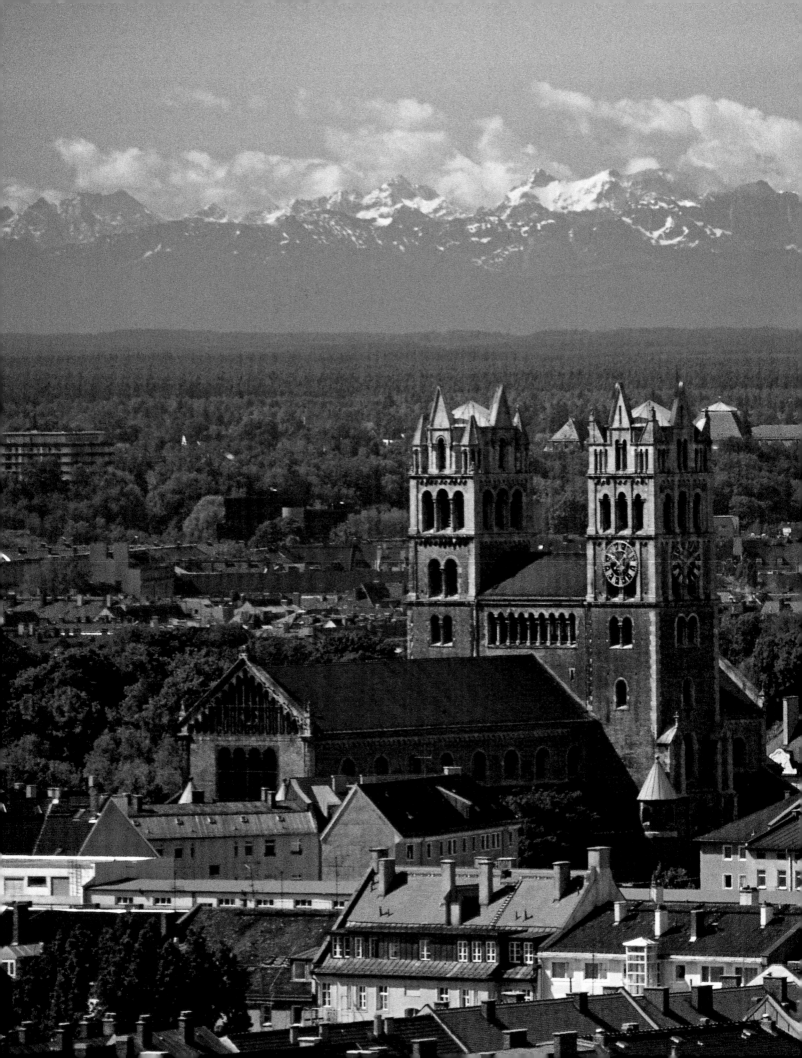

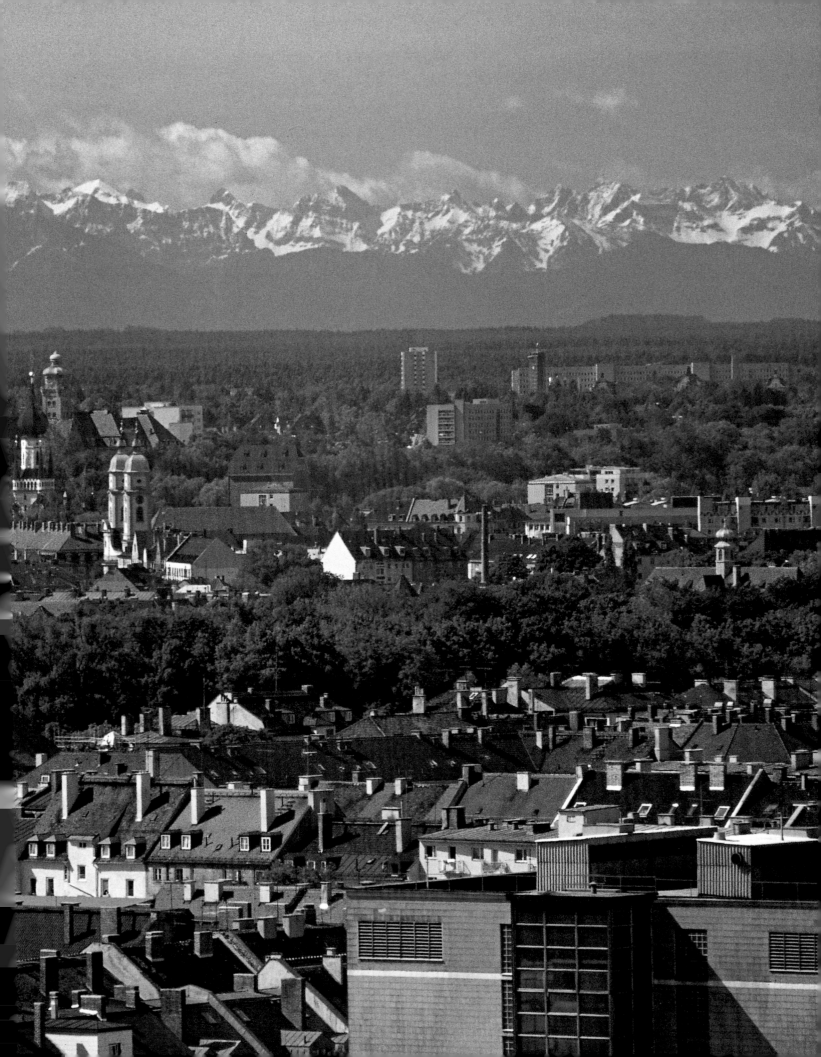

MUNICH – GLOBAL VILLAGE

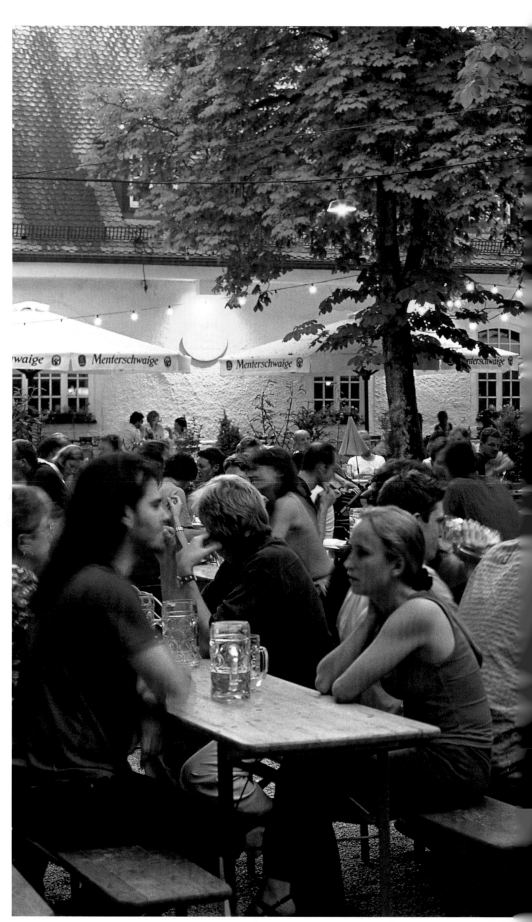

It doesn't matter how far away they are from home; the minute holidaymaking »Münchner« mention the name of their native abode faces light up and the words »Oktoberfest« and »Hofbräuhaus« are uttered – often barely discernible as such. Beamed into homes the world over via satellite, the cliché has stuck; across the globe Munich is firmly associated with just one thing: inebriated crowds in »Lederhosen« and shaving-brush hats brandishing enormous beer glasses from which they consume copious amounts.

In Germany itself the clichés are just as firmly ingrained, if somewhat differently slanted. To your average German Munich is the fashionable and incredibly expensive home of the nation's high society, of the country's yuppies, would-bes and has-beens. Munich itself couldn't care less what others think, putting it all down to sheer envy – possibly rightly so. After all, according to frequent polls which city has the highest standard of living and quality of life in the whole of Germany? What brings all those Northerners here, then, who in their enthusiasm for all things Bavarian present glowing cheeks for a traditional peck without being asked and kit themselves out in traditional »Dirndl« and »Lederhosen« yet still insist on their Northern »Tschüüüüs« when genuine Münchner say »Servus« on parting? Who's got the Alps on their doorstep, Italy within easy reach, lakes and rivers in abundance, a mild climate and Mediterranean »joie de vivre«? Need more be said?

In Munich these very Northerners are known as »Preißn« – regardless of whether they actually come from the same part of the world as Prussian ruler Frederick the Great or not. Rhinelanders, East Frisians and the good burghers of Hamburg and Frankfurt are all Prussians, according to the inhabitants of Munich. Making jokes about Prussians is a national sport – but not one to be taken

AND MODERN METROPOLIS

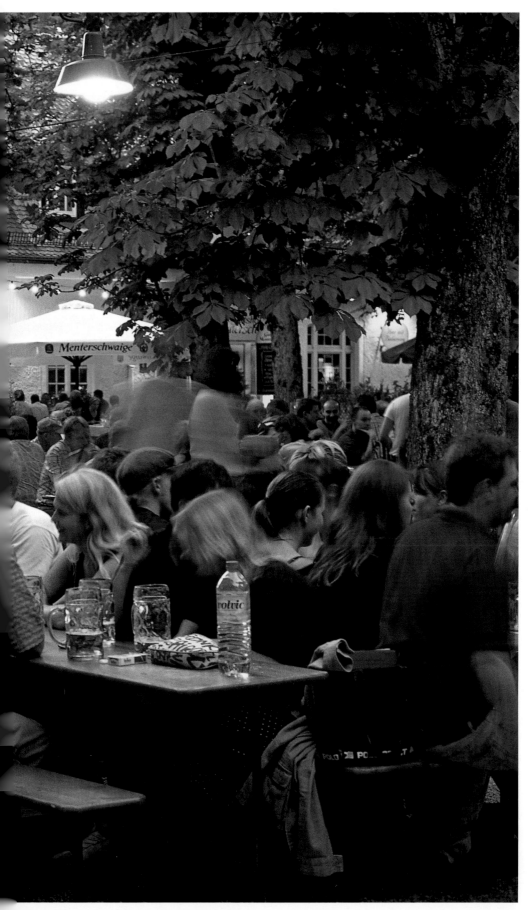

seriously. In Munich there's a strong sense of live and let live, with not only North Germans but also new citizens from much further afield made to feel welcome here. Without them the city would not be what it is: a major centre of commerce which countless international concerns have made their headquarters.

The baroque elegance, the compact, almost village-like flair of the city centre, the many expanses of green, the obvious enjoyment of the pleasures of life and the image created by the media – who naturally prefer to focus on characteristic costume rather than computer chips – all detract from the fact that Munich is actually an extremely modern and economically successful business venue. After Berlin it's the second-largest centre of employment in Germany and the market leader nationwide in information and communication technology and media and life sciences. With almost 280 assurance companies from home and abroad it's the hub of the insurance industry in Germany and second only to Frankfurt in banking. In publishing Munich is trumped only by New York. Of course the city is also feeling the pinch of the current economic recession and is having to make cuts alongside everybody else. Compared to the rest of the country, however, it's still doing pretty well.

SOCIAL DEMOCRATIC CAPITAL IN A CONSERVATIVE LAND

What a shame, then, that the (Conservative) minister of Bavaria can't count Munich among his successes. Apart from a very brief intermezzo starring the political right (Bavaria's Christlich-Soziale Union), which ended in scandal, the state capital has been ruled by Germany's left-of-centre Sozialdemokratische Partei Deutschlands (SPD) since 1948. A red-green coalition has been in power since 1990, with Christian Ude acting as Lord Mayor since 1993 – extremely successfully so, as election results have proved several times over. Munich is the Social Democratic capital of a Conservative »Bundesland«. And not for the first time. The last occasion in 1918, when a soviet republic was proclaimed in Munich, was less fruitful, however. With no further use for the monarchy the office of minister of Bavaria was created, with Kurt Eisner the first to hold the title. He

managed to push through several of his demands – Bavaria became the first German state to introduce votes for women and the 8-hour working day – yet beyond Munich Eisner had little support. At the local elections in January 1919 he fared badly and, shortly before he could gracefully step down, was assassinated by Count Anton von Arco-Valley. A second Munich soviet republic was then set up but this didn't last long; in May 1919 imperial troops and armed volunteers from the city environs – farmers in traditional mountain dress – marched on Munich and in two days of bloody battle beat the reactionaries into submission.

THE DARKEST CHAPTER IN THE CITY'S HISTORY

The way was then paved for what was to come next – and what must be the darkest chapter in the history of Munich – namely the rise to power of the National Socialists under failed Austrian artist and petty lance corporal Adolf Hitler. His ideas met with a fatal enthusiasm in a city rife with champions of the extreme right and anti-Semitism – and where the upholders of justice turned a blind eye. Hitler wasn't just popular with the general public; he also moved in higher circles, among them the one gathered about the publisher Hanfstaengel, through whom he could establish his contacts to influential industrialists and where he could escape to when his putsch failed.

Hitler's putsch took place on November 8 1923. It was planned as a march on Berlin but came to an abrupt halt outside the Feldherrnhalle where the Nazi party was declared illegal – which didn't stop party members continuing to spread fear and terror for one minute, tolerated by city officials. The trial of the ringleaders was a sham; foreigner Adolf Hitler wasn't even deported »because he thinks and feels in such a German manner« and his »five-year prison sentence« didn't even last twelve months.

The rest is history: a world war claiming millions of victims, millions who died in the concentration camps. What's not so well known is that Munich also put up plenty of resistance to the new oppressors. A man called Georg Elser, for example, made a daring attempt to assassinate Hitler in 1939. His plan sadly failed; his target left the Bürgerbräukeller earlier than expected and Elser's

Very similar to the Victorian abodes of turn-of-the-century London, this row of »Gründerzeit« houses lines the Kaiserstraße in Schwabing.

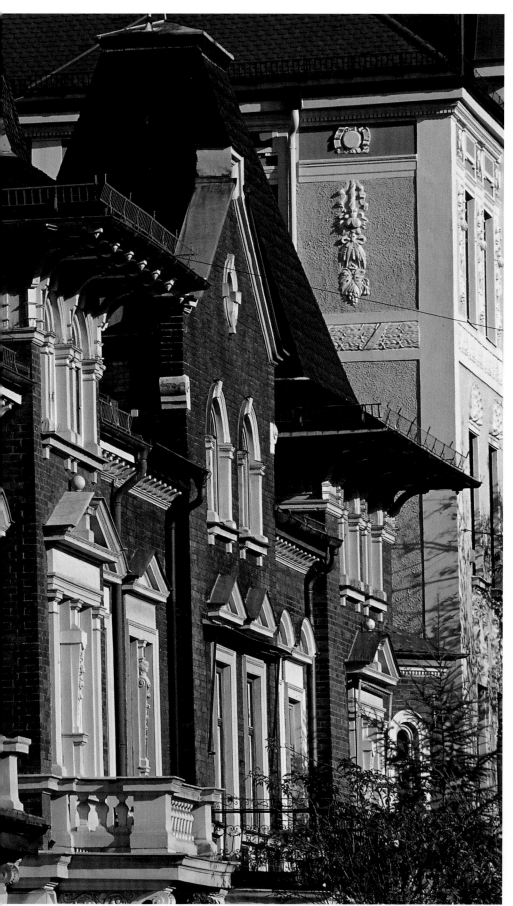

bomb just hit a few hangers-on. Elser died in Dachau. Jesuit priest Rupert Mayer was another bold individual who was deported to a concentration camp for preaching against the National Socialists. Brother and sister Sophie and Hans Scholl were two more, part of The White Rose resistance group of students and professors, who were caught distributing anti-Nazi leaflets at the university and executed in 1943.

Hitler had great architectural plans for his »capital of the Movement«, as he called it, wanting to redesign it so that »it would no longer be recognisable«. He did – but not quite in the way he envisaged. When the Americans marched into Munich on April 30 1945 the city was nothing more than a pile of rubble, destroyed by 3,500,000 bombs which demolished about half of the buildings in the city centre and 33% of the city as a whole. Writer Walter Kolbenhoff poignantly describes what the city looked like in 1946:

»Hesitantly I walked along the few paths which had been cleared among the debris towards a church and a large Gothic building which must have once been the town hall. One could see for miles and then was once again plunged into chasms surrounded by towering ruins. I had just wanted to see the city. But there was no city. There was just a soul-numbing desert. The people in this desert were like ghosts, men in threadbare uniforms, women in worn-out dresses and coats. Their faces were without expression, their eyes deep set and lifeless. I didn't see any children. I was gripped by a dreadful sense of loneliness and despair. Away from this place, I must away.«

As Lord Mayor Thomas Wimmer said at the time, Munich was »a pile of living rubble«. Munich had been reduced to 5 million cubic metres (176 million cubic feet) of detritus – almost enough to build the Great Pyramid of King Khufu twice over. Calculations made in 1946 as to the amount of material needed to rebuild the city estimated that if the bricks, mortar, steel and glass were used as they had been originally it would take until 2142 for the last stone to be laid.

NEW POLITICAL AND CULTURAL ORDER

The actual reconstruction of Munich was thankfully a lot quicker – not least thanks to the Americans. The occupying forces didn't

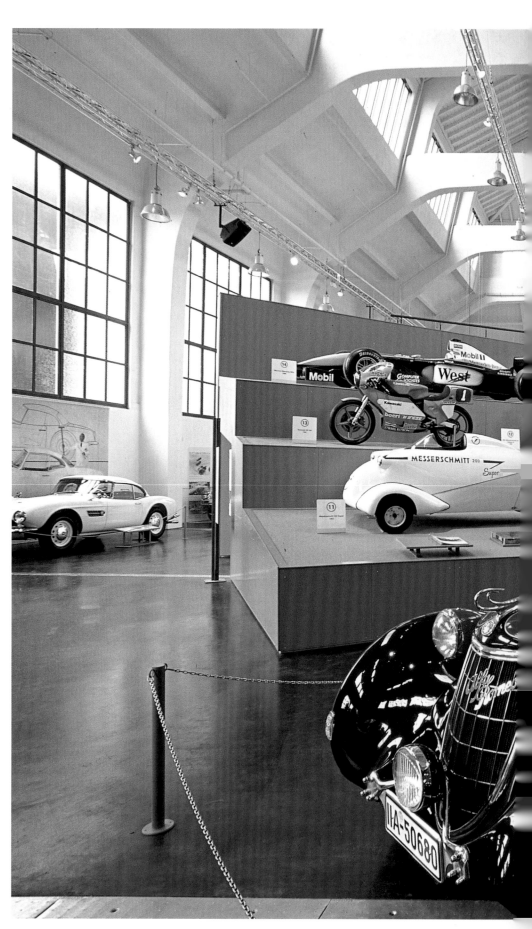

just help rebuild Germany; they also set the course for a new political and cultural order. Like the rest of the country Munich had deprived itself of its intellectuals; many of them, such as Lion Feuchtwanger, Thomas Mann and Oskar Maria Graf, had been forced into exile. Others, and especially those of Jewish extraction, had been murdered by the Nazis in their concentration camps. The Americans made sure that respectable, »de-Nazified« politicians were given key positions in the city's government and that the relaunch of the media was placed in the hands of licensed, trusted individuals. Erich Kästner, for example, played a major role in the revival of the arts, with Hildegard Hamm-Brücher excelling in local politics, then just 27 and the youngest woman councillor to hold office in Munich's town hall.

Looking back, there's cause to regret the speed with which the »Wirtschaftswunder« swept across war-torn Germany. In the course of its rebirth many of Munich's historic buildings were dynamited, great numbers of which had either survived the air raids intact or could easily have been restored. A strong view to the future and the need to suppress the recent past, however, were the determining factors of the architecture of the post-war era – and it's perfectly understandable, of course, that the conservation of ancient monuments wasn't exactly a priority when 300,000 people were homeless and in desperate need of a roof over their heads.

This merry disregard for past fabrics wasn't just a feature of the immediate post-war years, with buildings of historic interest being demolished well into the 1970s. Munich wanted to be »car-friendly«, forcing an ugly dual carriageway right through the heart of the old town. In 1972 Munich hosted the Olympic Games and was eager to present itself to the world as a modern, glittering city; one result of this obsession was the Kaufhof department store on Marienplatz, nothing less than an architectural monstrosity of the first order. It was the lovechild of a star-struck city council who lauded the facade as a »particularly fortunate and individual Munich solution«, ordering a wonderful, miraculously unscathed »Jugendstil« house to be blasted to make way for the lump of con-

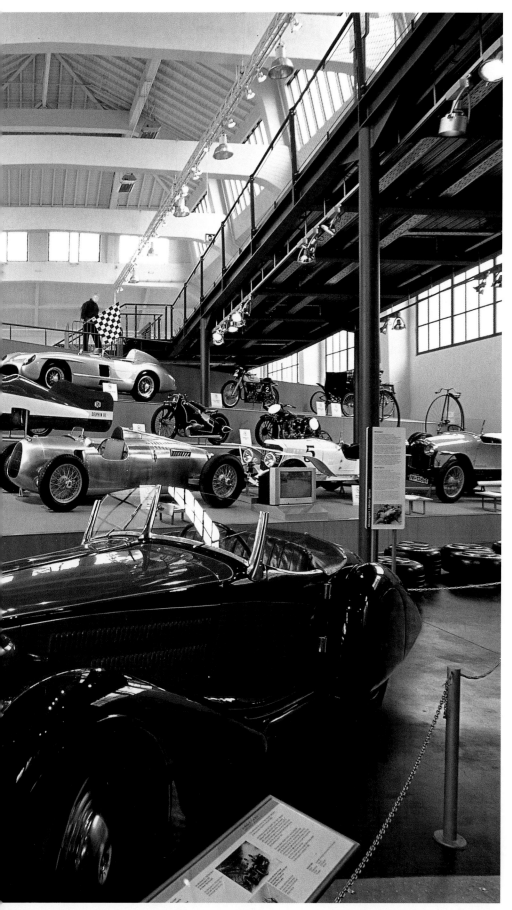

crete now disgracing the otherwise historic Marienplatz. Not all of Munich's attempts at modernism have fallen foul, however. The Olympic Stadium with its glass tent roof and the new Pinakothek are more aesthetically pleasing examples of the city's thirst for the state of the art.

Despite the war and the modernist whims of the city council Munich has managed to cling to much of its former splendour, with many a magnificent edifice to delight locals and visitors alike. Its present layout dates back to the first half of the 19th century and is largely the work of Ludwig I. Even before he ascended to the throne in 1825 the crown prince was responsible for all of the city's civil engineering projects; under his auspices Munich positively exploded. Until 1791 the entire city was contained within one set of walls which roughly followed the course of today's Altstadtring; only three city gates – the Isartor, Karlstor and Sendlinger Tor – have survived. The medieval town within was a splendid jumble of Gothic architecture, with prestigious buildings such as the Altes Rathaus and the Frauenkirche eloquently symbolising Munich's success as a centre of trade; later Renaissance and Baroque palaces and churches still document its long history as a royal seat.

APUD MUNICHEN –
MONKS' PLACE

Public life in the Middle Ages revolved around Schrannenplatz, named after the corn market which regularly took place here. This is where jousting tournaments were staged, where the local court and executions were held and where festivals were celebrated. The square was renamed Marienplatz in 1854 and is still the focal point of Munich and the best place from which to explore the city. Just off Marienplatz is the Church of St Peter – or Alter Peter as it's known locally – the place where Munich began. The first settlers on the Petersberg were monks after whom Munich is named. It's not known exactly when the brothers first came here. There is, however, evidence that the settlement already existed when Henry the Lion, the duke of Bavaria, built a bridge over the River Isar to enable salt to be transported via »apud Munichen« (»monks' place«). The bishop of Freising, who subsequently suffered heavy losses in his own dealings with the salt trade, was not amused and began a

Top right:
In a proper Bavarian beer garden like Menterschwaige it's quite acceptable to bring your own picnic with you. You can, of course, also buy your Bavarian staples (white radish, cheese, sausage and pretzels) at one of the pub's food stands.

Bottom right:
The opening of the Maidult fair on Mariahilfplatz is a cause for celebration.

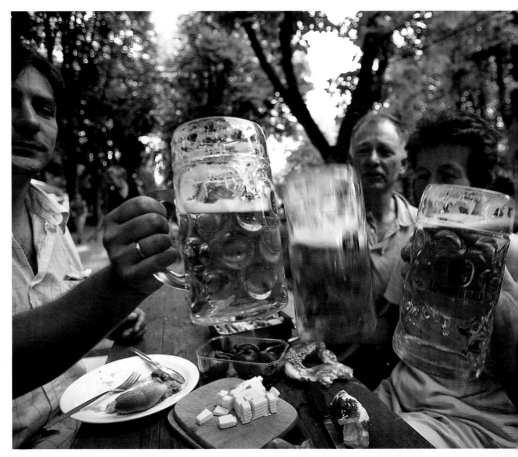

vicious feud with the gloating Henry. Emperor Frederick Barbarossa I was forced to intervene and drew up a document allowing the people of Munich to hold a salt market, levy market taxes and mint coins. The decree was made in 1158; as it's the oldest surviving document pertinent to Munich, 1158 has been taken as the year of the city's founding. In 1180 Henry the Lion fell out of favour and the emperor gave Bavaria to the Wittelsbach dynasty who made Munich their seat of power, ruling here until 1918.

Whether stagnation, progress, cultural growth or provincial vegetation, the fate of Munich has always been inextricably linked to the whims and whimsies of its rulers. And to those of the Catholic church. The Reformation never really took hold here; the Enlightenment passed Munich by and the Revolution of 1848 concentrated not on democracy and civil rights but on the affair of Ludwig I with dancer Lola Montez. It was his amorous dealings which eventually forced the king to abdicate – and not his supremacy of rule over Munich and Bavaria.

Ironically, however, it was Ludwig's thirst for power which propelled Munich into the modern age and helped it become the artistic metropolis it is today. In 1825 he moved the university from Landshut to Munich, forcibly persuading the city to make a name for itself in the sciences during the 19th century. Scholars of renown who researched and lectured here include Justus von Liebig, Carl von Linde, Joseph Fraunhofer, Max von Petterkofer and a lady of aristocratic pedigree, one Therese of Bavaria, who was the first woman to be accepted by Bavaria's academy of sciences.

Ludwig I was also absolutist in his architectural endeavours. Together with his star architects Leo von Klenze and Ludwig von Gärtner he laid out the monumental Ludwigstraße and Königsplatz and built four public museums: the Glyptothek, the Alte and Neue Pinakothek and a great hall for exhibitions of art and industry. He had the

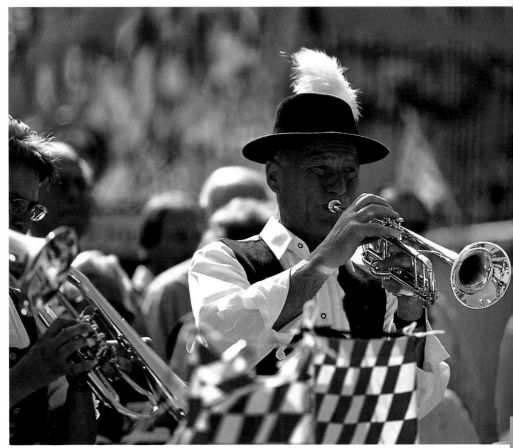

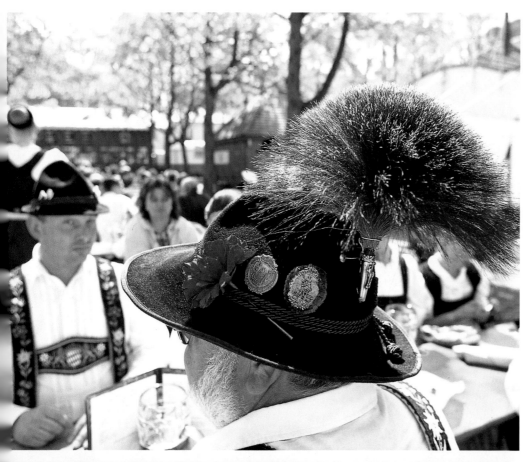

Top left:
*No Bavarian hat would
be complete without the
obligatory »shaving
brush«: the bigger the
better!*

Bottom left:
*Fish kebabs, pieces of
mackerel or trout skewered
on a stick, are barbecued
over an open fire at the
Auer Dult fair.*

royal palace extended and improved and
commissioned numerous monuments and
statues, such as the Siegestor, Feldherrnhalle
and Propyläen.

Like his father before him King Max II
was also a great patron of the sciences and
the arts and especially of literature. He also
continued to build, adding the magnificent
Maximilianstraße to a rapidly growing
Munich. It was perhaps the most famous of
Bavaria's kings, the dreamy Ludwig II, how-
ever, who did least for his royal capital. He
was an avid lover of music, championing the
work of Richard Wagner, yet visited town as
little as possible, hiding away in his fairytale
palaces out in the Alpine countryside.

Munich's monarchs also bequeathed to
the city its two most famous attractions. The
Oktoberfest, or Wiesn as it's known in
Munich, was first held in honour of Crown
Prince Ludwig's marriage to Princess Therese
von Sachsen-Hildburghausen in 1810. The
Hofbräuhaus, as the name suggests, was the
royal brewery.

As Munich is automatically associated
with beer, it may surprise you to learn that
the brew hasn't always been the city's num-
ber one beverage. Wine was predominant
until well into the 15th century. A change in
the climate at about this time meant that it
suddenly became too cold for the vines to
thrive near the city and wine had to be im-
ported. This proved extremely expensive and
so beer was drunk instead. In 1516 the duke
of Bavaria passed Germany's famous purity
law which stated that beer may no longer be
diluted and must only contain hops, barley
and water. In its improved form beer became
the new wine, consumed in vast quantities
by both the king and his subjects. So much
beer was poured down the royal throats at
court (110,000 litres/193,600 pints a year)
that it was deemed necessary to set up a
brewery for the king's private consumption.
The Hofbräuhaus was built for the exclusive
use of the court in 1589 and only opened to
the general public in 1828. In 1897, then just
a pub and no longer a brewery, it was moved
to its present location on Platzl. The enor-
mous Schwemme bar inside the building is

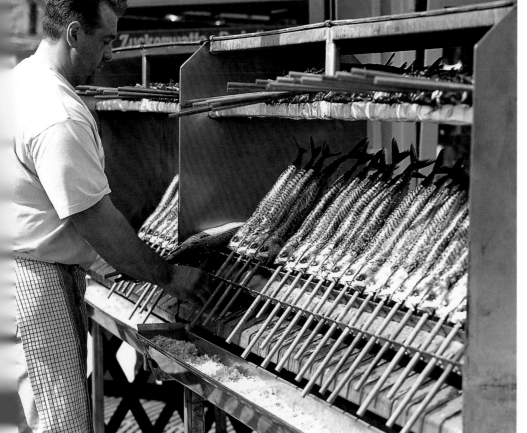

as lively as it was on its reopening; a quieter drink can be had in the beer garden outside in the courtyard.

UP TO THE CELLARS
FOR A BEER

Supping a cool beer in a oasis of green in summer is one of more sublime pleasures of Munich. Any self-respecting publican with a patch of grass and a few tables and chairs at his disposal is thus keen to advertise his out-side space as a fully-fledged beer garden, which is often a bit of a swizz. A genuine beer garden in Munich has to meet two all-im-portant criteria; it must be shaded by huge chestnut trees and allow visitors to consume their own food on the premises. It can then call itself a beer garden in keeping with the long tradition which goes back to the purity law and stipulations for brewers of 1539. These new decrees stated that between April 23 and September 29 beer was not to be manufactured due to the increased risk of summer fires which could be sparked during the boiling process. Envisaging lines of thirsty drinkers pounding angrily at their doors, in March brewers suddenly began working like frenzy, producing huge quanti-ties of a special beer which could keep longer if stored in a cool place. Cellars were enthu-siastically dug – but due to Munich's high water table these weren't deep enough; ad-ditional shade had to be provided above ground. Nothing was too much trouble in the name of beer; the earth was moved – lit-erally – to create mounds on which to plant shady chestnut trees. The summer could then begin! Thirsty punters flocked to the new watering holes (or rather, hills), much to the chagrin of local publicans who were not at all pleased that the breweries were selling direct to the public. To prevent an all-out war a law was passed which permitted breweries to sell their own beer but not food, meaning that visitors to the cellars had to take their picnic with them.

In the great traditional beer gardens of Munich – such as the Chinesischer Turm, Aumeister and Menterschwaige – this still applies. People come armed with wicker hampers, checked tablecloths and outdoor candles, with plates, knives, cheese, sausage and radish, order a beer and settle down to enjoy themselves. Friends are met, either by arrangement or chance. New friends are made as people join those already seated if

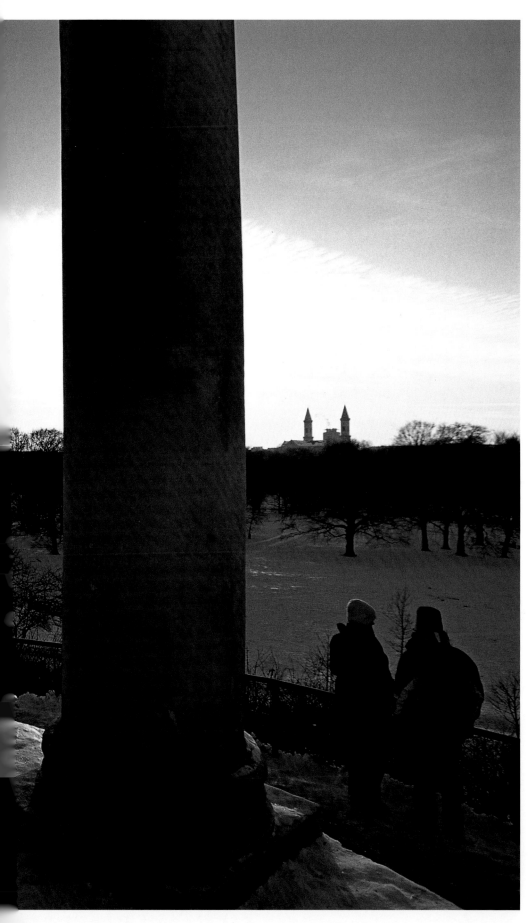

Slap bang in the middle of the Englischer Garten is a round Greek temple on a man-made mound, the Monopteros, built in 1838 by Leo von Klenze. The folly has fantastic views out across the park and the city.

there's enough room on the bench. Dogs run around and children play. And if you've forgotten your picnic, don't worry; there are plenty of stands selling hot and cold specialities.

And thus the conversation turns inevitably to food, a topic which in Munich, where life is lived to the full, is of major importance and should be studied in practice, not theory. If you want some personal advice, take a stroll across the colourful Viktualienmarkt until your mouth is positively watering. Then turn off onto Westenrieder-straße just a couple of hundred yards away and trot along to Sedlmayr's. Authentic in its hospitality and decor – with none of your plastic Bavarian kitsch – the prices are reasonable and the food is excellent, with fresh white sausages available in the mornings and the full range of local dishes served according to the season. Tinned and frozen ingredients are dirty words here; the boss himself personally oversees the goings-on in the kitchen and makes sure that all the sauces and dressings are home-made and that the high standard of Bavarian cooking is maintained. Items on the menu include soup with liver dumplings, roast pork with a crisp crust, tongue of veal, boiled trotters and offal. If you're not sure what »Briesmilzwurst« or »Münchner Gansjung« are, it doesn't matter. Just ask one of the waiters or waitresses or do as the locals do; be brave and try it. After all, the proof of the pudding is in the eating...

Page 24/25:
Park Nymphenburg, surrounding the palace of the same name, was laid out as a baroque pleasure garden in 1715. Just 100 years later it was revamped as an English landscaped park by Friedrich Ludwig von Sckell, who also designed the famous Englischer Garten.

Page 22/23:
When Munich celebrates its founding on Marien-platz, it does so in style, complete with local costumes, music and spectacular »Schuh-plattler« dancing.

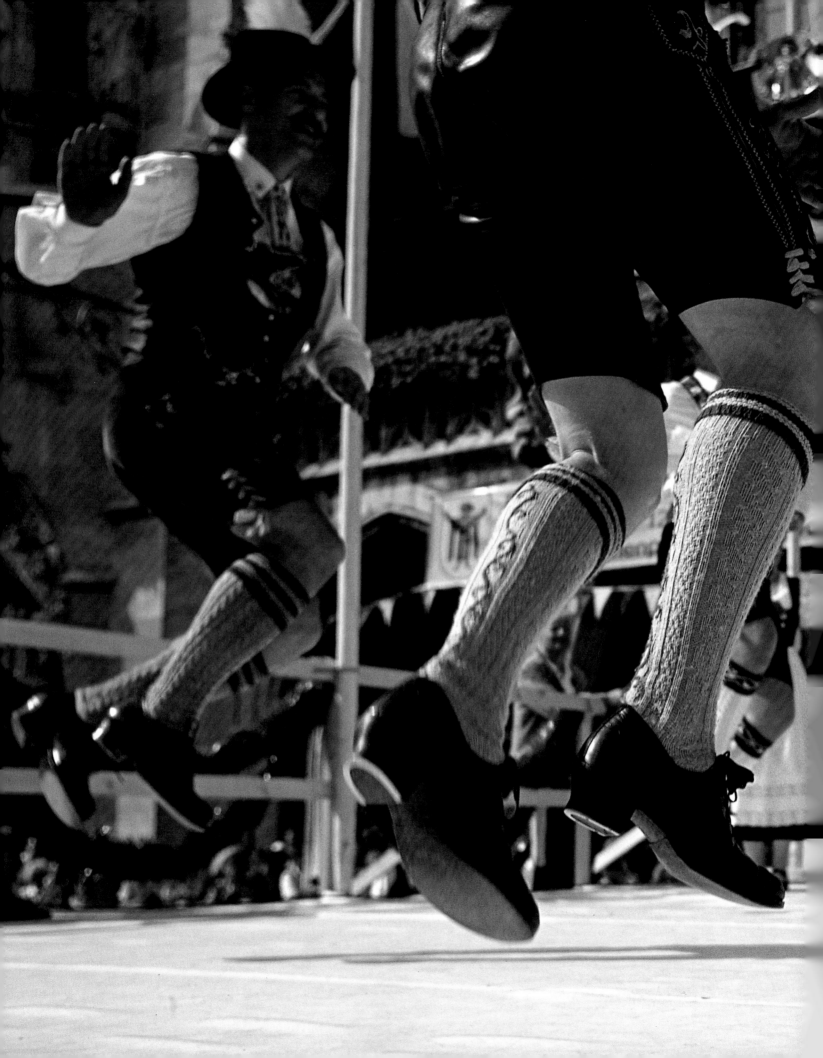

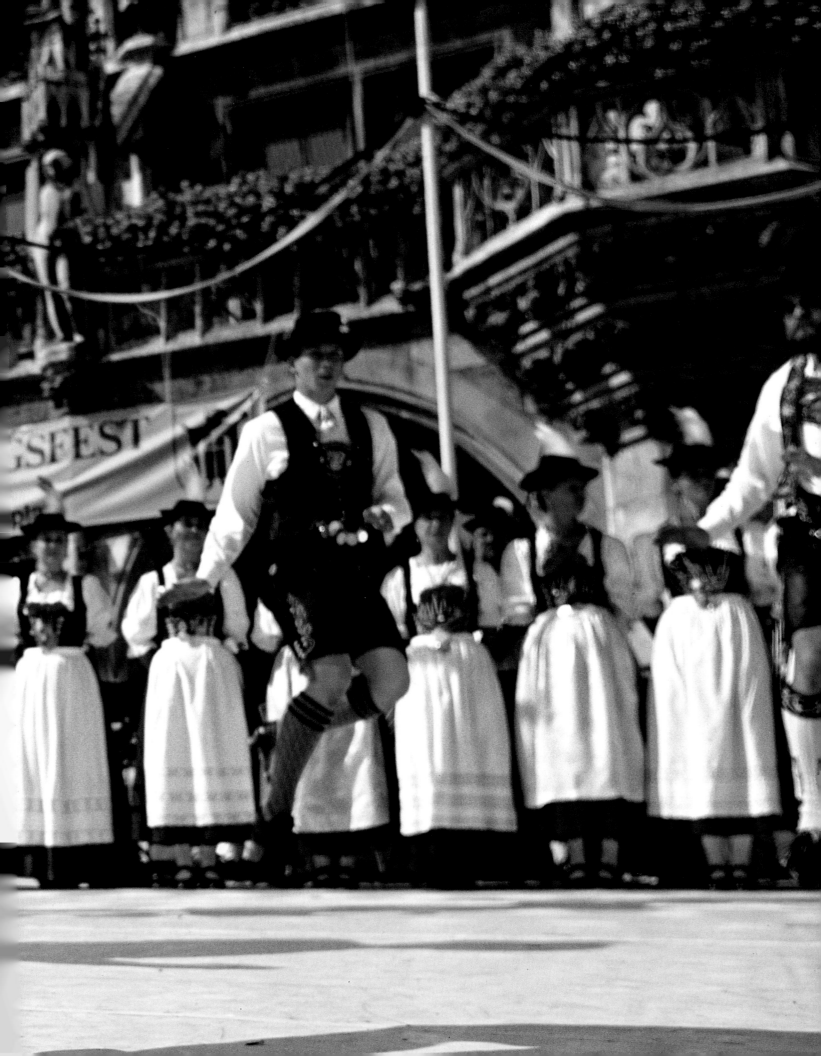

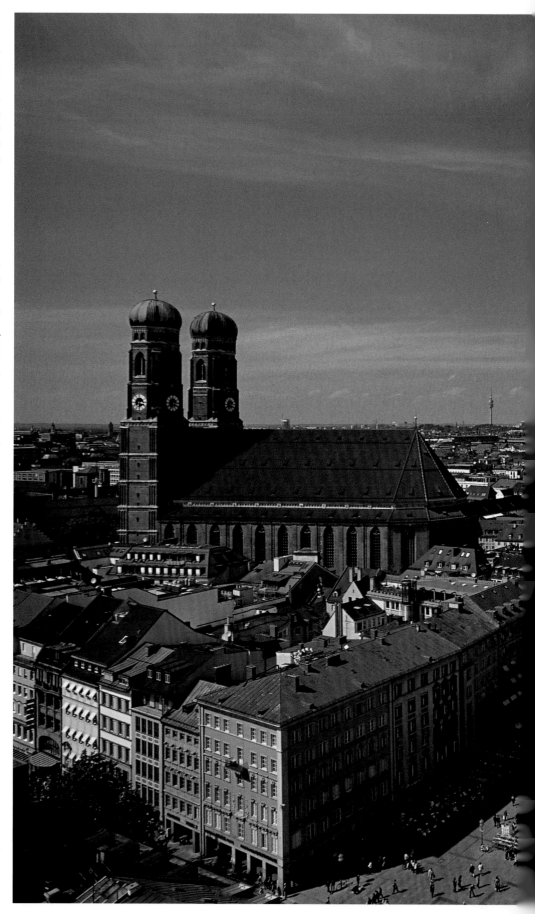

The Neues Rathaus or new town hall, which dominates Marienplatz, was erected in the neo-Gothic style between 1867 and 1908. Its lofty tower is dwarfed only by the twin spires of the Frauenkirche.

The centre of Munich is small and easy to find your way around, with one main square and two high streets running from north to south and east to west which cross it. The limits of today's city centre are largely determined by the Altstadtring, several lanes of ring road which follow the course of what were once the outer city walls, the second line of defences erected in the 15th century.

It's best to start your foray out into Munich on Marienplatz. Here stand the old and new town halls (Altes and Neues Rathaus), the latter with its famous carillon, and Alter Peter, the oldest parish church in Munich with grand views from (and a long climb to the top of) its lofty spire. An absolute must is the Viktualienmarkt, the all-week market, before meandering down to the Isartor, one of the three city gates still standing, which now houses the museum dedicated to Karl Valentin.

The Isartor's opposite number is the Karlstor which is reached along Kaufinger and Neuhauser Straße. Here the boutiques and department stores are punctuated by elegant churches, among them Munich's local landmark, the majestic Frauenkirche with its twin onion domes.

On Sendlinger Straße, which terminates at Sendlinger Tor, the spectacular Asamkirche is well worth a visit; more shopping can be done on Theatiner Straße which leads towards the district of Schwabing. For those with slightly more money at their disposal the chic establishments of Maximilianstraße await, beginning on Max-Joseph-Platz with the opera house and royal Residenz. The Maximilianstraße itself is very close to Platzl with the Hofbräuhaus; here you shouldn't miss the Alter Hof (old castle) and Münzhof (royal mint) before treating yourself to a well-earned beer at what must be the most famous public house in the world.

CITY WALLS

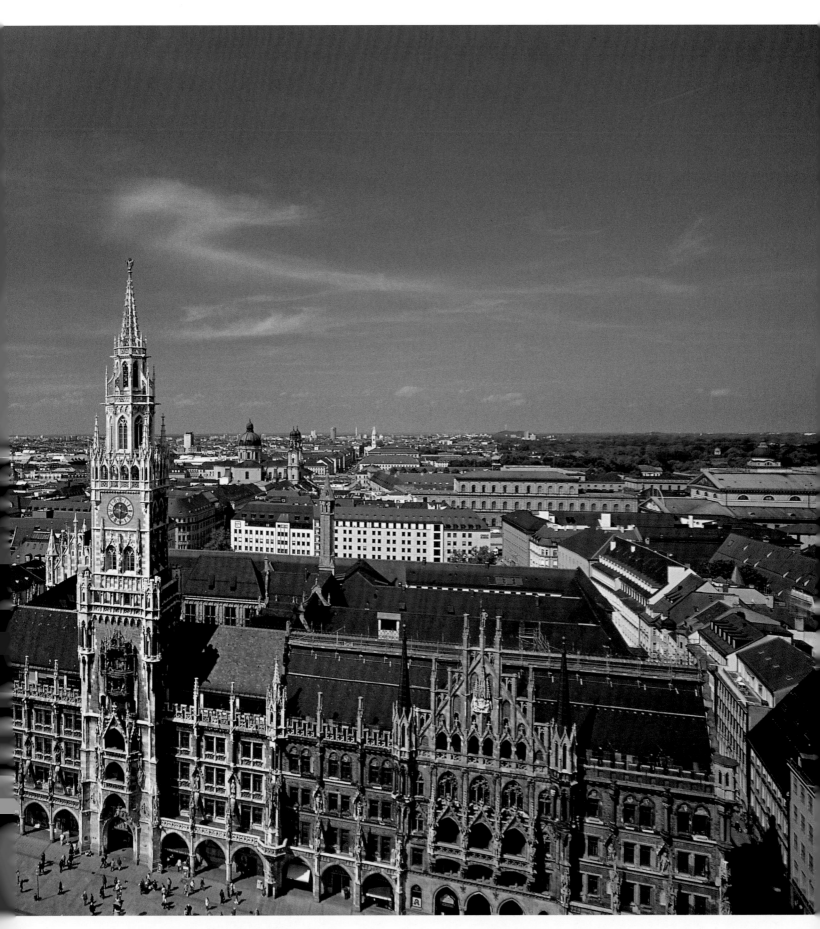

27

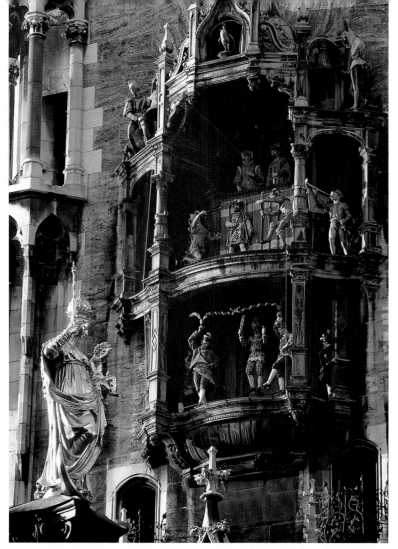

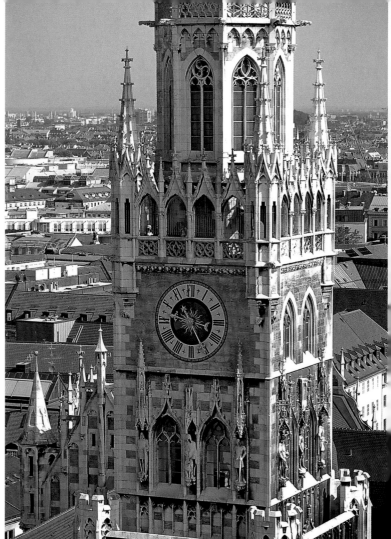

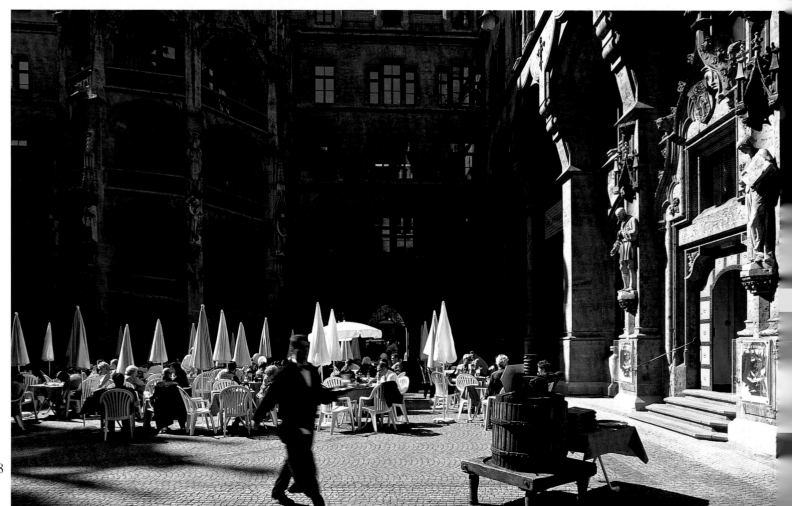

Far left:
Munich's most popular
carillon on Marienplatz
has 32 life-size figures
which joust and dance in
time to its 43 bells.

Left:
The chimes are set into
an ornamental bay in
the town hall tower high
up above the crowds who
gather here several times
a day to enjoy the show.

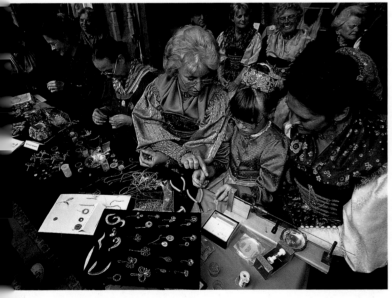

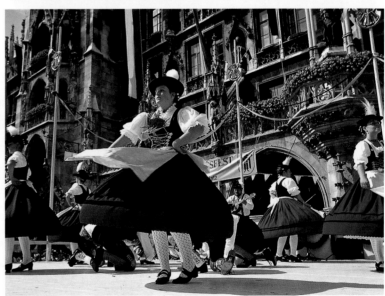

eft:
here are six inner
urtyards within the
nfines of the Neues
athaus, the most
pressive being the
unkhof with its spiral
ircase tower.

**Small pictures,
above:**
Each summer Munich
celebrates its founding at
the colourful Stadtgrün-
dungsfest. Regional
dances and national
costume are permanent
fixtures of the event,
with modern groups and
international performers
also invited to spice up
an otherwise traditional
programme. Food and
drink are also naturally
in abundance.

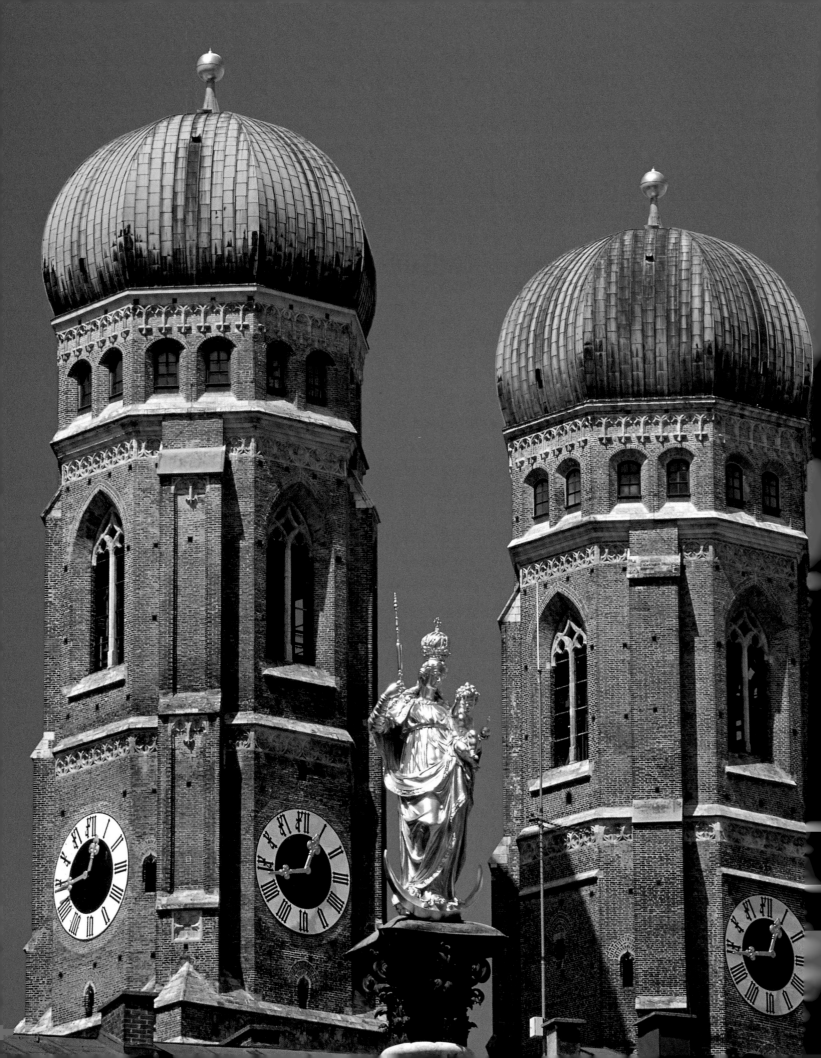

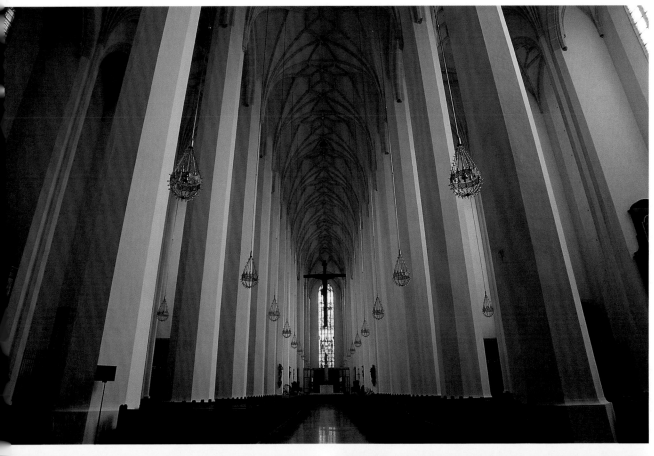

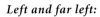

Left page:

A golden effigy of the Madonna looks down from on high from the Mariensäule on Marienplatz. The twin towers of the Frauenkirche behind her are topped by two characteristic domes, a Renaissance addition from 1525; the church itself is Gothic, begun in 1468.

Left:

The interior of the Frauenkirche, dedicated to the Virgin Mary, can accommodate up to 20,000 – 7,000 more than were living in the city of Munich at the time of the church's construction.

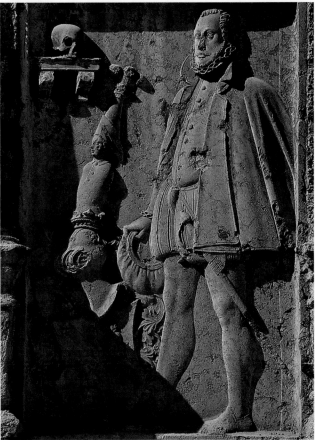

Left and far left:

Embedded into the outer walls of the Frauenkirche are 120 historic tombstones. Some are so badly weathered that the inscription they once bore is no longer legible. Others depict coats of arms, historic figures and memento mori.

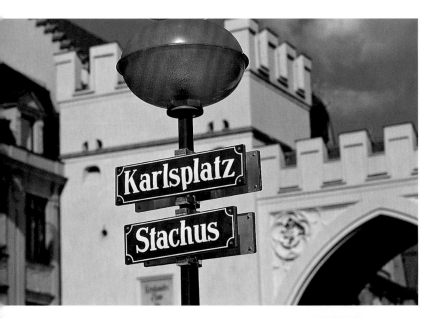

Top left:
The official name of this square in Munich is Karlsplatz; the locals, however, insist on calling it Stachus after Eustachius (Stachus) Föderl *who once had a pub here. The name Karlsplatz, introduced by Elector Karl Theodor at the end of the 18th century, never really stuck – and maybe never will.*

Centre left:
Neuhauser Straße, one of the major shopping drags in town, branches off from Stachus towards Marienplatz. The street was pedestrianised in 1966.

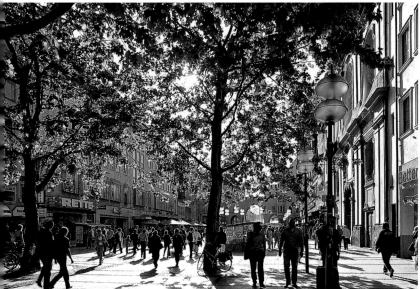

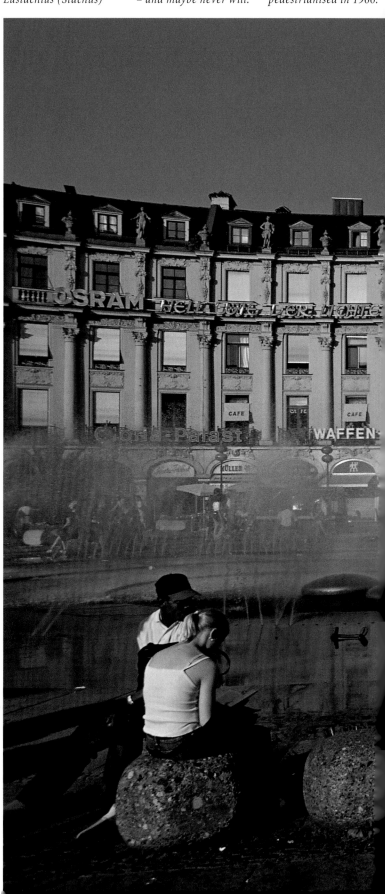

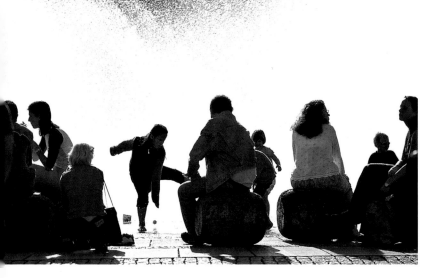

Bottom left:
Stachus was once one of the busiest crossroads in Europe. Now there are benches and a fountain offering welcome respite from the summer sun.

Below:
At the point where Neuhauser Straße peters out onto Stachus stands the Karlstor, one of the old city gates from the early 14th century. The squat towers are much later, from the end of the 19th/beginning of the 20th centuries.

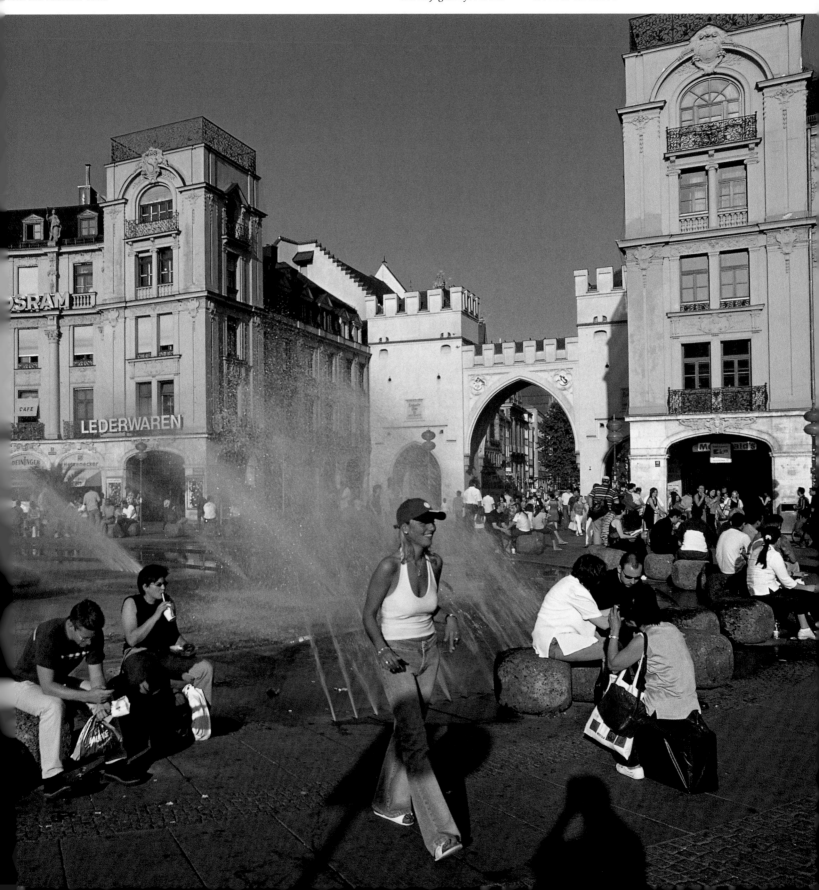

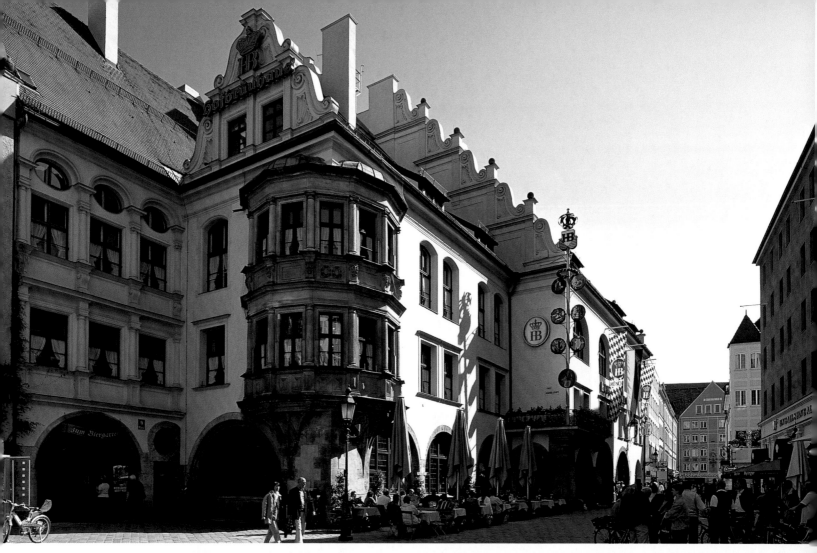

Above:
This is it, the top attraction in Munich: the Hofbräuhaus. As the name suggests, in the days of yore only courtiers were allowed to drink at Munich's royal brewery. Today it's open to everyone and enjoys a large and extremely cosmopolitan clientele.

Right:
Another of the city's great traditional hostelries is the Hackerhaus on Sendlinger Straße. Here the atmosphere is more restrained than at the Hofbräuhaus, with guests dining quietly in the peaceful summer courtyard.

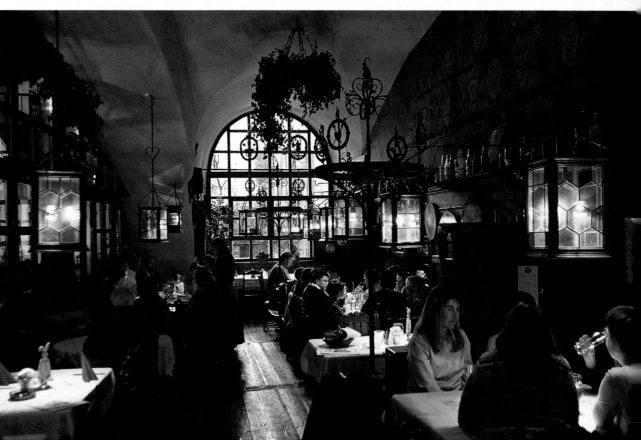

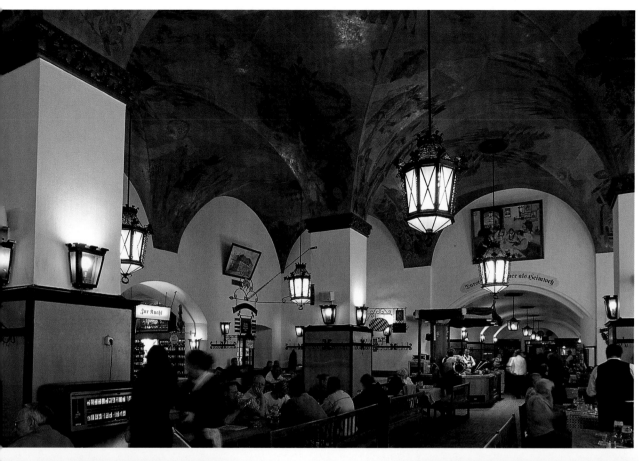

Left:
Over one hundred tables are reserved for regulars in the public bar or Schwemme at the Hofbräuhaus. These are zealously guarded; un-invited visitors should avoid sitting at a »Stammtisch« at all costs!

Below:
Not everybody in Munich flocks to the Hofbräuhaus. Many avoid it, not realising that the courtyard has a very pleasant beer garden far from the madding crowds of the Schwemme.

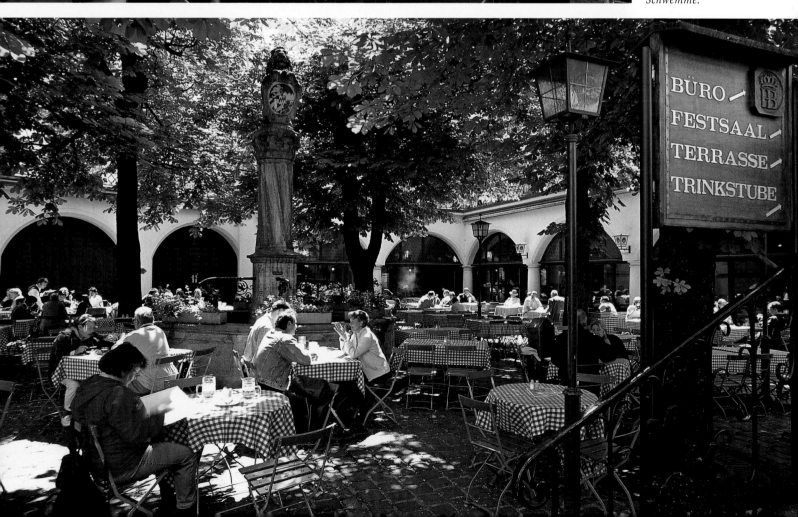

OFTEN COPIED BUT NEVER BEATEN

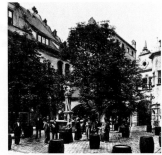

The further into September you get, the more one topic hogs the headlines of Munich's less eloquent local rags. The talk of the town is the Wiesn, more commonly known to lesser mortals as the Munich Oktoberfest which is emulated with much gusto in many countries across the globe. Whenever a huge crowd gathers together for the sole purpose of consuming enormous quantities of beer (with a few fairground rides thrown in for good measure) the whole jamboree goes under the name of Oktoberfest – much to the chagrin of the Münchner.

For none of these gutsy copies is a patch on the original. And, to be honest, we know – which is why we flock to Munich in our millions each autumn. The people of Munich know too – which is why they spend the weeks in the run-up to the big bun fight whinging about it. The biggest moan of all is the price of beer. This goes up every year – and every year the locals are heard to proclaim loud and long that at such disgustingly high prices they definitely won't be going to the »Fest« this time around. Anyway, they add hotly, it's not been that good for years and there's no room in the marquees because all those big heads (Munich-speak for the rich and influential) have pre-booked, not even leaving enough space for a man to have a quiet beer or two in the comfort of his own tent.

When Munich moans, the press moans. And then, suddenly, it's the last Saturday in September. The streets are cordoned off and the floats and wagons trawl through the heart of town, with horses pulling cartloads of beer in precariously stacked barrels and coaches carrying the Lord Mayor of Munich and the president of Bavaria, with smiling groups in local costume and marching bands playing oompah music. The gates to the Wiesn have barely been officially opened when the people of Munich come in their droves – many of them in their Bavarian Sunday best – to meander past the booths and rides, breathing in the mixed aromas of burnt almonds and fried fish and listening to the plastic lion roaring »Lööööööweenbrääääu« and intrepid punters screaming their heads off on the big dippers and ghost trains. They inevitably end up in one of the beer tents – where there's plenty of space after all – and obediently raise their frothing mugs to the raucous tones of »Ein Prosit, ein Prosit der Gemütlichkeit«, all the time marvelling at the strength of the waitresses armed with dozens of beer glasses apiece who bang them down unceremoniously on the long tables. For the next two weeks Munich finds itself in a drunken state of emergency. Friends, relatives and casual acquaintances hail each other with the words »Been to the Wiesn yet?« and there's hardly a soul who answers »No«.

FROM HORSE TO HIGH-TECH: THE FESTIVAL'S FAIRGROUND ATTRACTIONS

The first Oktoberfest took place in 1810. It was the only one where nobody had any complaints about the price of the beer as the king was footing the bill. Crown Prince Ludwig was celebrating his marriage to Therese Charlotte Louise von

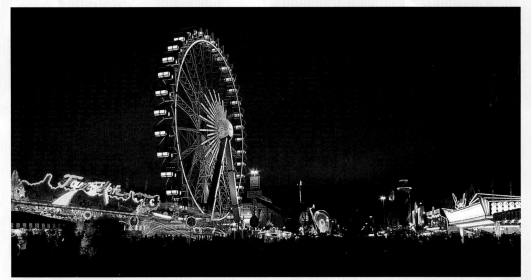

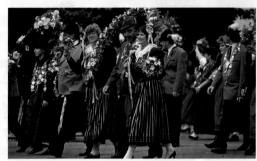

Right:
For politicians the opening parade is an ideal opportunity to rub shoulders with their constituents. Here, Bavarian minister Edmund Stoiber waves to passers-by.

Right:
The opening of the Oktoberfest is heralded by a procession in local costume, with each group carrying elaborate floral garlands.

Left:
At the Wiesn only local Munich breweries are allowed to pull a Pils. Each brewery has its own special tent.

Page 36 above:
Even 100 years ago visitors liked to take their beer out into the garden of the Hofbräuhaus, built between 1896 and 1897.

Page 36 below:
The bright lights of the Wiesn, best seen from the top of the Big Wheel slowly revolving above the merry throng.

Sachsen-Hildburghausen and had invited his loyal subjects to partake in the festivities. 32,065 loaves of bread, 3,992 pounds of Swiss cheese, over 80 tons of roast mutton, 8,120 cervelats, 13,300 pairs of smoked sausage, around four hectolitres of wine and 232 hectolitres of beer were distributed among the people in the middle of Munich. Outside the centre at Sendlinger Tor, where the road branched off towards Italy, horse races took place which proved so popular that they were held again the following year at an agricultural show staged to pump new impetus into local farming.

The races stopped in 1938 and since its spectacular beginnings the festival has greatly changed. The mainstay of the jollities has always been – and probably always will be – beer. It was served at the first races, albeit not on the infamous Theresienwiese but on Sendlinger Anhöhe. In later years the sale of beer was permitted within the race track itself, where makeshift stalls selling food and drink were quick to become a permanent feature of the event.

Fairground attractions held little significance in the early years; it was only after the Unification of Germany in 1871, when the country experienced a nationwide boom, that the number of sideshows increased. Today the Oktoberfest has everything the wizards of the high-tech ride can throw at us, the staple of any self-respecting funfair from Düsseldorf to Disneyland. Nevertheless, Munich's Oktoberfest is and will remain absolutely unique. The many poor copies the world over are living proof.

Below left and right:
*Kaufingerstraße and
Neuhauser Straße link
Marienplatz up with
Stachus, both pedestri-
anised and a mecca for*
shopaholics. There are
exclusive boutiques
but also branches of the
major department stores
for the more moderately
endowed.

Right:
*On the north side of
Platzl square, where the
Hofbräuhaus also stands,
is the Orlandohaus,*
erected in 1899. Recently
completely restored, the
building is now the Or-
lando Keller restaurant.

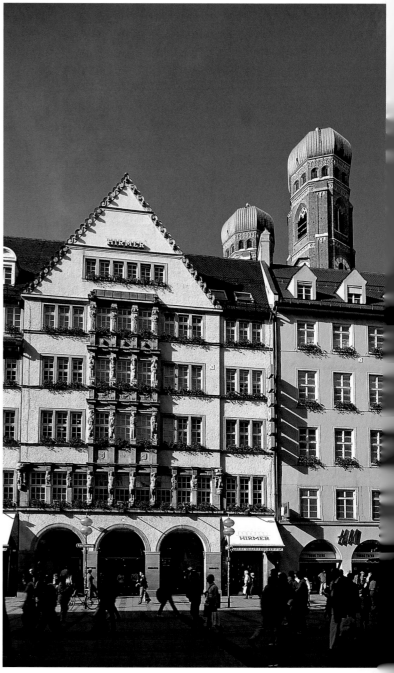

**Right page,
centre left:**
*The Augustinerbräu
brewery on Neuhauser
Straße serves typical
Bavarian fare. One of
the best places to sit is
outside in the ornate
courtyard.*

**Right page,
centre right:**
*Haxnbauer on Spar-
kassenstraße specialises
in pork and veal joints
which slowly roast on
long skewers on the grill
until the skin has formed
a crisp, golden crust.*

**Right page,
bottom left:**
*The Weißes Bräuhaus on
Tal is famous for its
excellent wheat beer, a
top-fermented beverage
which is available here
in both its light and dark
varieties.*

**Right pag...
bottom righ...**
*Tiny alleyways lead o...
Platzl into the restore...
inner courtyards ...
ancient town hous...
from as far back as t...
14th centur...*

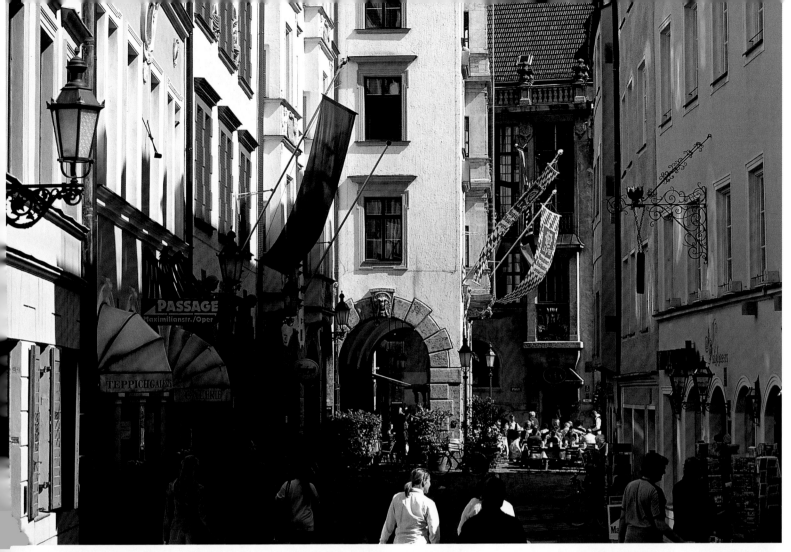

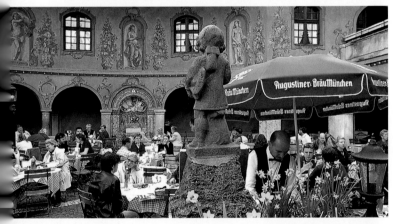

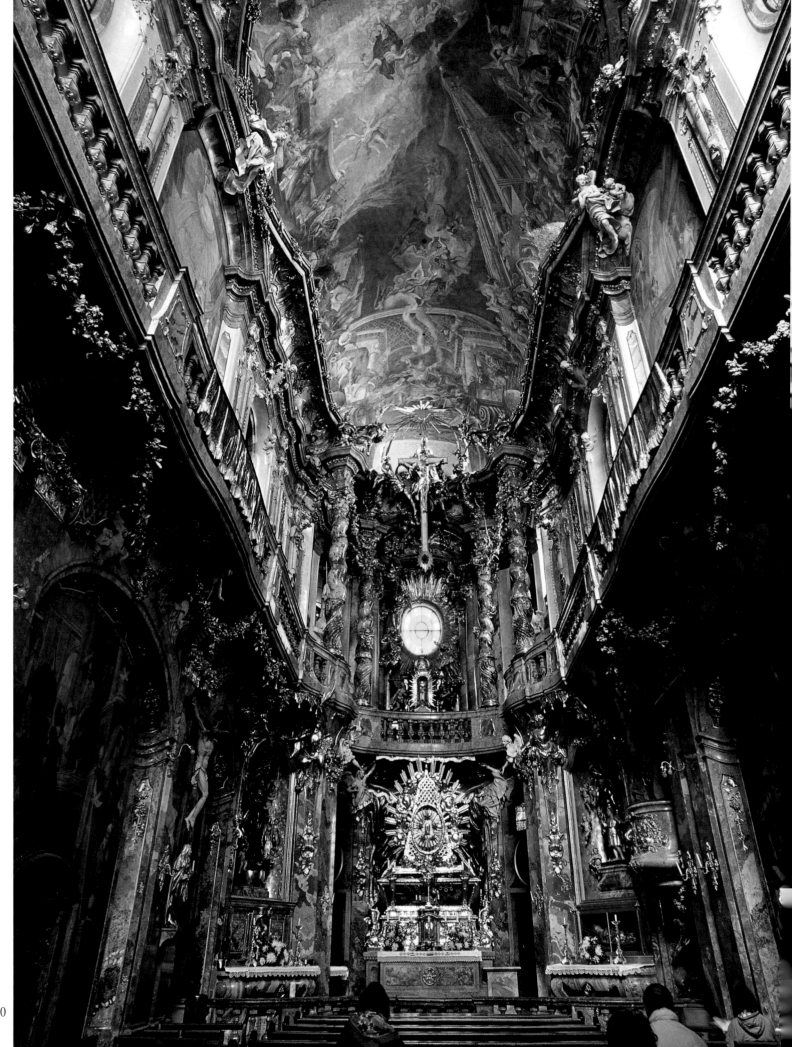

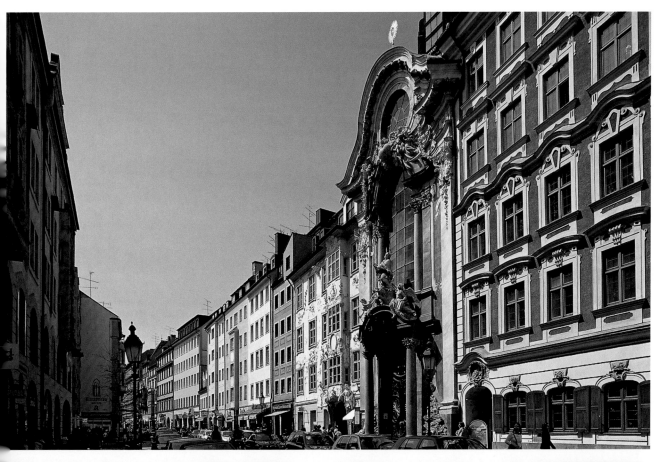

Left page:
Gold, marble and a heavenly host of cherubs positively overwhelm the unsuspecting visitor entering the Asamkirche on Sendlinger Straße. The magnificent work of the brothers Egid Quirin and Cosmas Damian Asam, completed in 1746, it's said to be one of the most beautiful baroque churches in Bavaria.

Sendlinger Straße, running from Marienplatz to Sendlinger Tor, is firmly punctuated by the decorative facade of the Asamkirche, flanked on either side by the Asam-Haus and Priesterhaus.

Detail of the facade of the Asam-Haus. Egid Quirin Asam built next door to the church he and his brother had created, with a window allowing him to admire the high altar from the comfort of his own home.

41

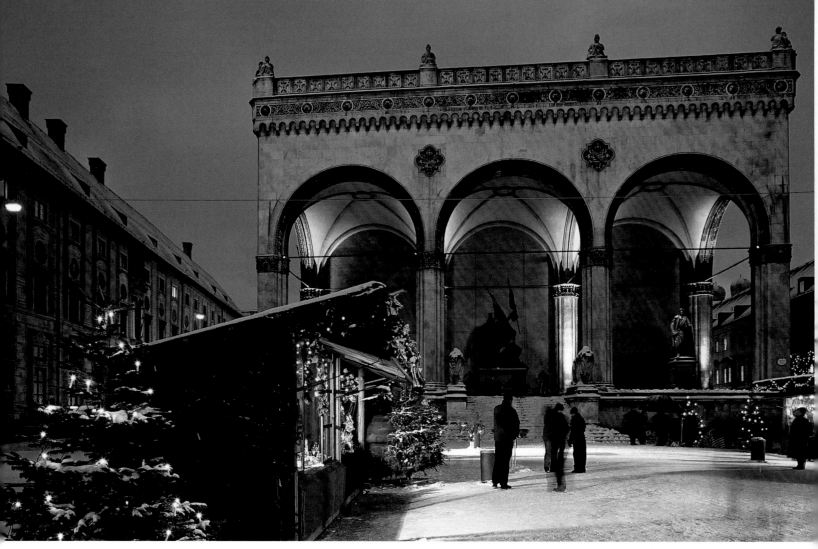

Above:
In the run-up to Christmas Advent markets abound in Munich. Here stallholders peddle their seasonal wares in front of the Feldherrnhalle on Odeonsplatz.

Right:
With the Alps not far away, winter in Munich can be harsh and very cold. The Hofgarten beer garden now lies deep under a blanket of snow.

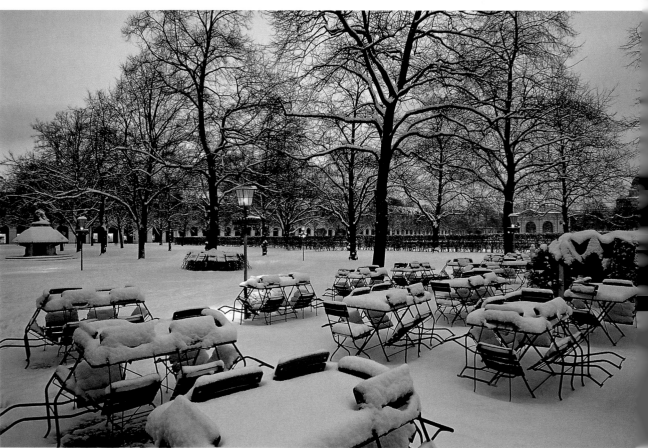

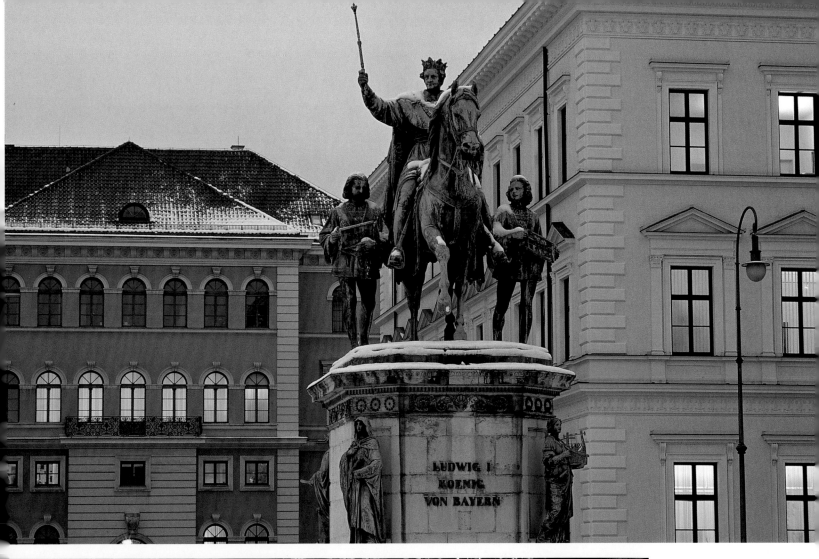

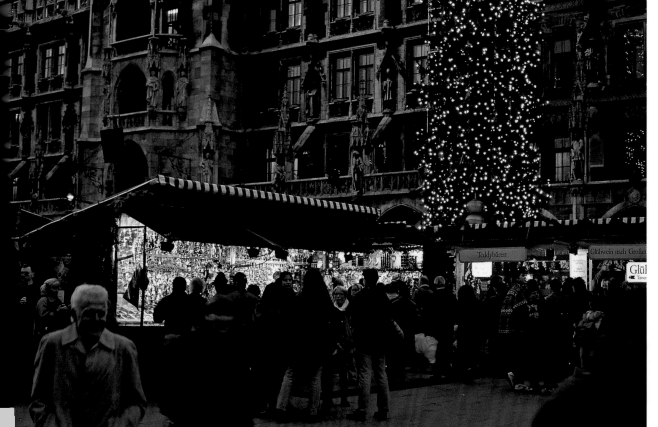

Above:
Ludwig I permanently changed the architectural face of Munich during the first half of the 19th century. He was responsible for the Ludwigstraße, for example, which starts at Odeonsplatz. Here he is remembered, high up on his horse.

Left:
A few weeks before Christmas an enormous tree is erected in front of the Neues Rathaus and Marienplatz turned into a buzzing Christmas fair.

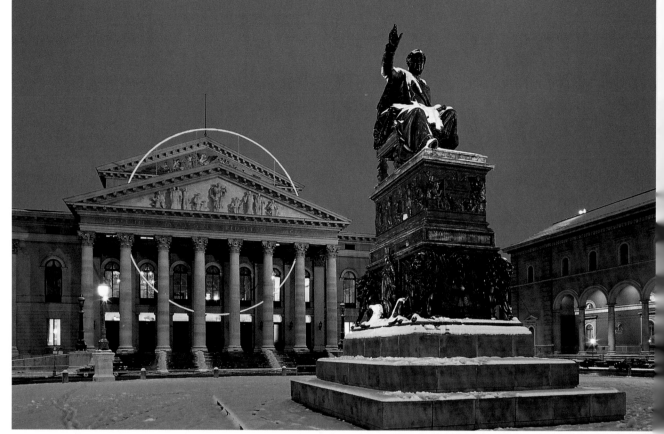

Munich was badly damaged during the Second World War. The national theatre, the opera house from 1818, was also hit by a bomb, leaving just the outer walls intact. It was only reopened, after painstaking reconstruction, in 1963. The monument outside it is dedicated to Max Joseph I, the first king of Bavaria.

Munich's most famous delicatessen, Alois Dallmayr, is on Dienerstraße. Those who can afford it come here to buy delicacies from across the globe. Even if you're just window shopping, Dallmayr's is well worth a visit.

Right page:
Behind the new town hall, slap bang in the centre of Munich, is a rare and coveted open space – Marienhof – which has been the subject of much debate as to whether it should be developed or not. Skaters are glad it hasn't been; in winter they can skit across the ice here to their heart's content.

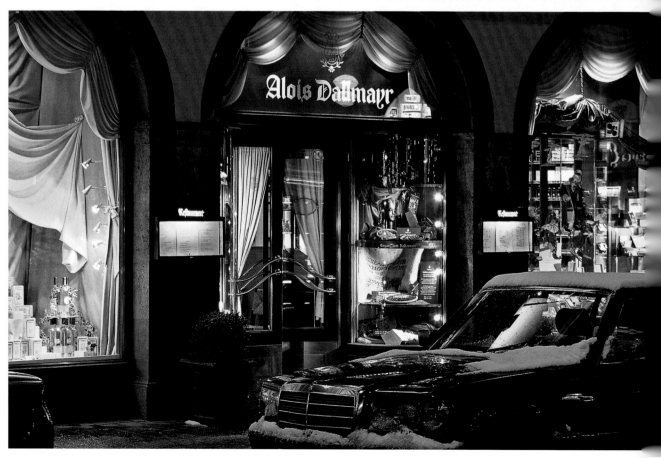

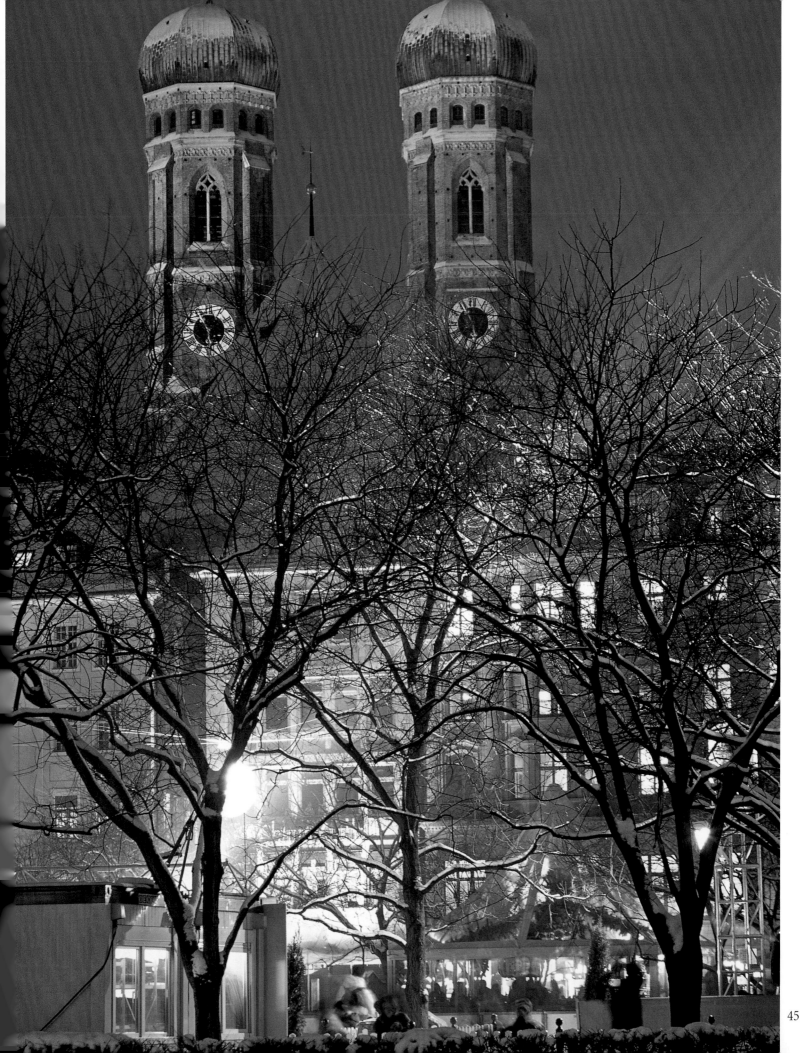

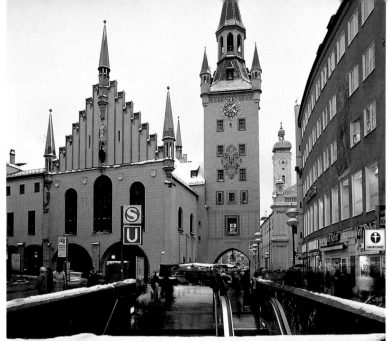

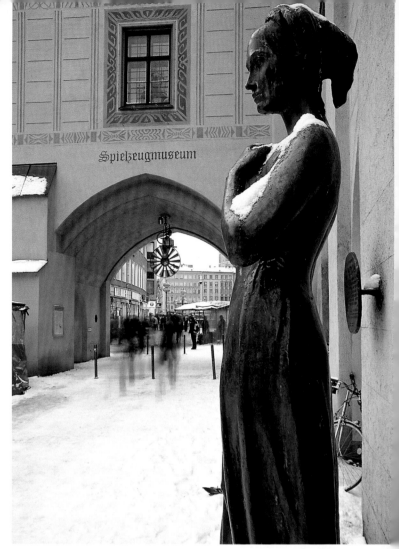

Above:
In weather like this it's best to head for Munich's nice, warm underground. The old town hall, its Gothic gable covered in snow, looks on in the background.

Above right:
Next to the Altes Rathaus Julia, the beloved, takes shelter from the cold. The figure was presented to Munich by its Italian twin town Verona.

Right:
Theatinerstraße, between Marienhof and Odeonsplatz, is lined with fancy shops and boutiques and usually very busy. In winter time, however, shoppers not surprisingly prefer the warmth and comfort of the interior of the Theatinerhof…

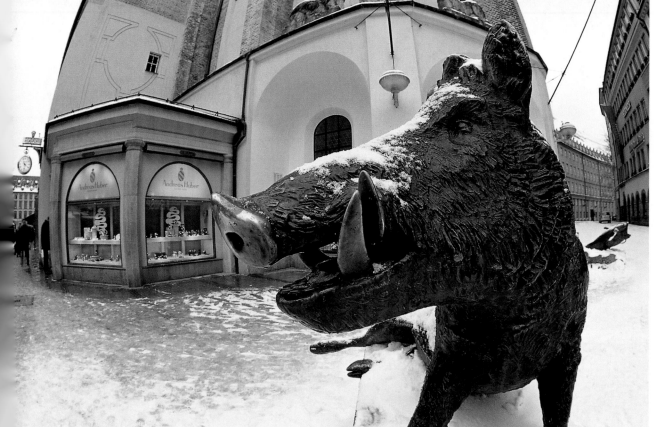

Above:
A winter evening on Ludwigstraße, with the baroque Theatinerkirche from 1688 in the background. The facade was completed in 1768 in the style of the Rococo.

Left:
Outside the museum of hunting and fishing on Neuhauser Straße stands a rather fierce-looking wild boar with a very shiny nose, pawed by many an intrepid passer-by.

Right:
*The state chancellery seen
from the Hofgarten. Most
of the people of Munich
consider the modern
colossus – with the old
army museum sand-
wiched in between it –
an architectural abomi-
nation. In front of it, set
into the ground, is the
memorial for the dead of
the First World War.*

Below:
*Munich was once a royal
capital and has a great
many palaces which
housed the members of
the king's court. Palais
Portia, here on Kardinal-
Faulhaber-Straße, has a
particularly splendid
Rococo facade. Behind it
is the Frauenkirche.*

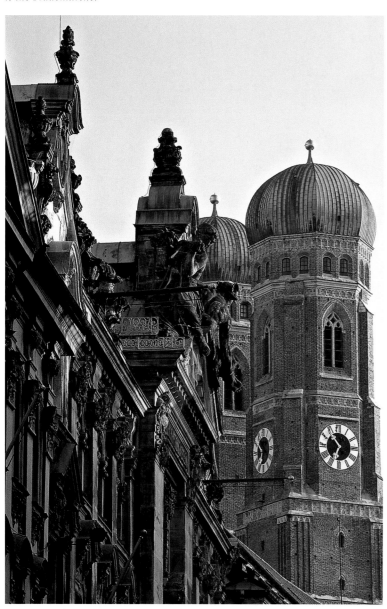

Above:
*Together with New York
Munich is one of the
world's strongholds of
the publishing industry.
It's hardly surprising,
then, that literature is*
*highly rated here; it even
has its own centre on
Salvatorplatz, next to
the Salvatorkirche, where
readings and other liter-
ary events are held.*

Righ[t]
*Tucked away [on]
Hofgraben ne[ar]
Maximilianstraße [is]
Münzhof, an absolu[te]
gem with its wonderf[ul]
arcaded Renaissan[ce]
courtyar[d.]*

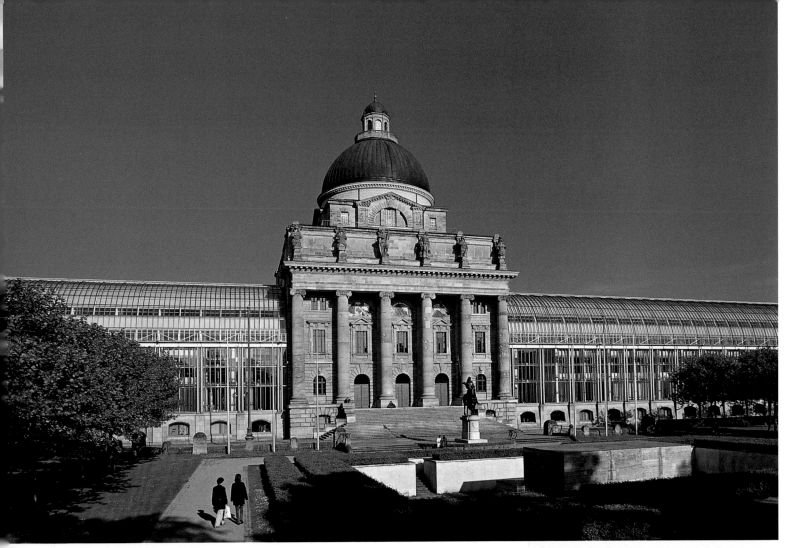

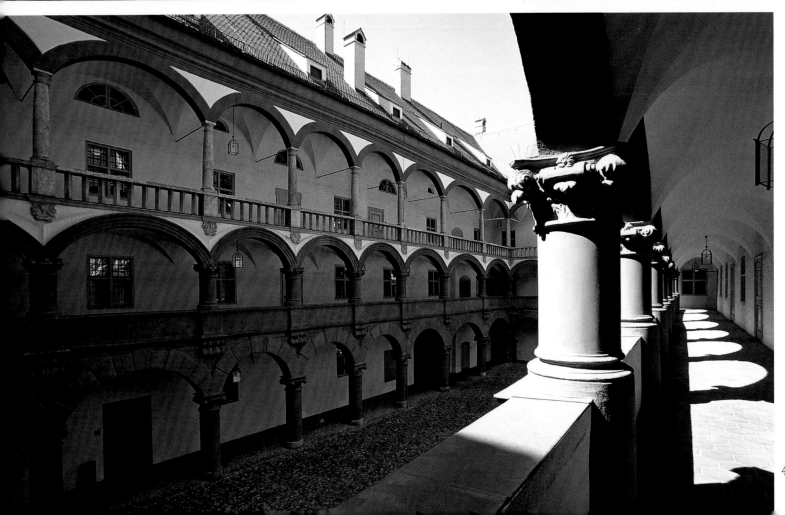

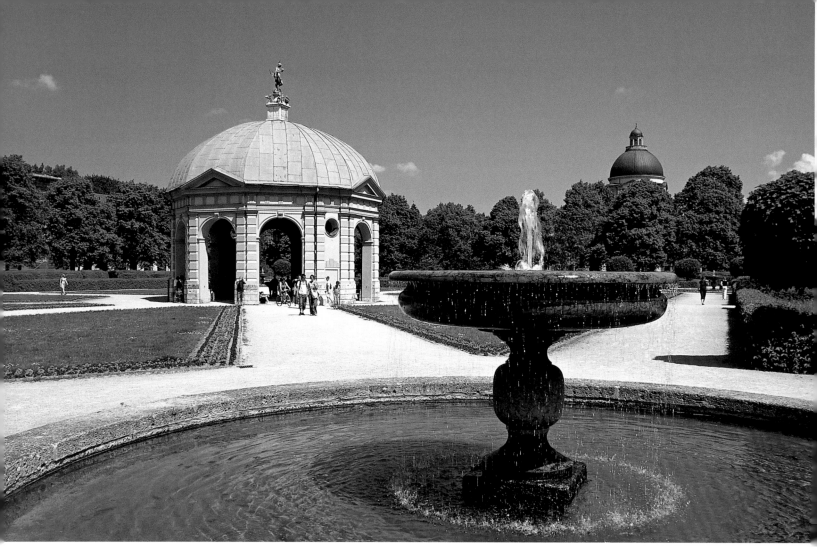

Above:
Duke Maximilian I was looking to the parks of the Italian Renaissance for inspiration when he had his Hofgarten laid out behind the royal palace between 1613 and 1617. A small temple bearing a statue of Diana forms the centrepiece.

Right:
The days when the Hofgarten was reserved for the king's courtiers alone are long gone. The gardens are now a popular place to meet and have a drink or two at one of the many cafés and restaurants.

Left:
The neo-Renaissance Künstlerhaus on Lenbachplatz was built at the end of the 19th century to house Munich's artists' cooperative.

Below:
The beautiful Wittelsbacher Brunnen on Lenbachplatz, with its carved horse and bull, was installed in 1895 to celebrate Munich being connected up to mains water.

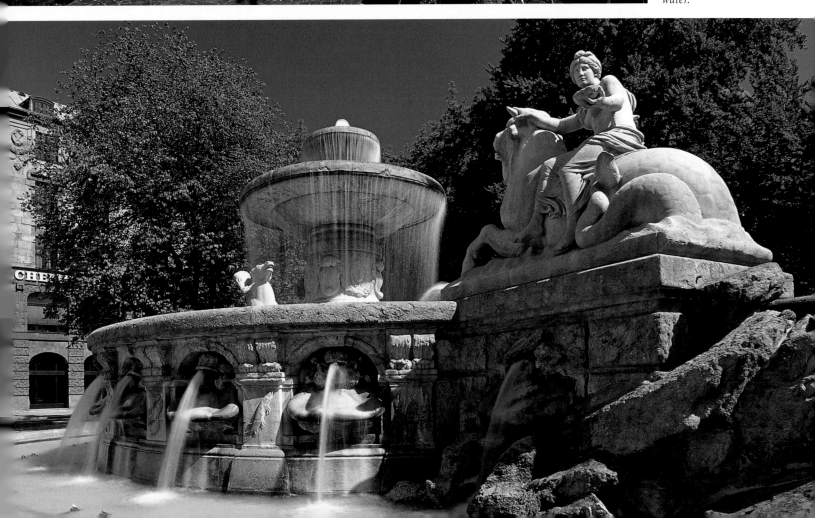

MUNICH'S MUSEUMS

Franz Marc was a member of Der Blaue Reiter. He drew much of his inspiration from the Bavarian countryside; here he's shown on a hiking tour of the Alps.

ART AND TECHNOLOGY; FROM THE ANCIENT GREEKS TO ASTROPHYSICS

Lovers of art and architecture should meander along to the Kunstareal München on Barerstraße. The complex is one huge art gallery, the 2002 opening of the Pinakothek der Moderne finally rounding off the city's comprehensive collection of art from all periods of its history. The Alte Pinakothek, built between 1826 and 1836, houses a world-famous collection of Old Masters from the 14th to the 18th centuries, among them works by Dürer, Rubens and Rembrandt. The original Neue Pinakothek, also erected by Ludwig I, suffered such grave damage during the Second World War that it

Munich boasts no less than 45 museums. Among them are such curiosities as ZAM or the Zentrum für Außergewöhnliche Museen, the home of the weird and the wonderful on Westenriederstraße, where the exhibits range from the chamber pot to the pedal car to the

Below, far left:
The Lenbachhaus on Luisenstraße attracts art lovers from all over the world. It holds a famous collection of works by Der Blaue Reiter and many others.

Below left, centre:
The master of the house, Franz von Lenbach, was one of the great portraitists of the 19th century who made enough money from his paintings to build this splendid villa and garden.

Left:
The Glyptothek on Königsplatz, built by Leo von Klenze in the early 19th century, has an excellent collection of ancient sculptures and statues.

Far right:
The Neue Pinakothek has a collection of European art of the 19th century. After admiring the exhibits, you can enjoy a drink at the gallery's Caffè Greco outside the postmodernist concrete and granite building.

Right:
August Macke's »Mädchen im Grünen« glow in brilliant colours. Macke was also one of Der Blaue Reiter.

Below:
Franz Marc's »Blue Horses«. He first painted in the style of the Impressionists, later adopting an expressive abstract style with pure colours and crystalline forms.

Easter Bunny. Just around the corner, in the tall tower of the Isartor, is the Valentin-Musäum, dedicated to local comedian Karl Valentin. The deliberate misspelling of the German word for »museum« is just one of the oddities you can ponder upon once you've paid your 199 cents entrance fee. There's a melted snow sculpture, for example, the hook which Valentin slung as a carpenter and plenty more silliness to keep you bemused.

There are also the potato museum, theatrical museum, toy museum, film museum, Alpine museum, city museum ... It's hard to decide just which ones to visit, especially if you've only got a few days here. Which are an absolute must? What shouldn't you miss in cultropolis Munich, which also has 57 theatres, two opera houses, seven major orchestras and many international festivals to boot? Plus an impressive number of music venues, cabarets, clubs, halls and galleries ... But we digress. Let's just stick to the museums.

had to be torn down. The new building by Alexander von Branca, completed in 1981, focuses on European art of the 19th century. Whereas Branca's postmodernist edifice was a veritable bone of contention, architectural critics are united in their effusive praise of Stefan Braunfels's Pinakothek der Moderne. Here, art, graphics, architecture and design are all collated under one roof, the historical spectrum ranging from the classic heroes of modernism, such as Beckmann, Klee and Picasso, to contemporary art in all its wacky diversity.

Art aficionados also shouldn't miss the gallery in the Lenbachhaus on Luisenstraße, not far from Königsplatz and the Antikensammlung and Glyptothek, where the art of the Ancient Greeks, Romans and Etruscans is on display. The Lenbachhaus concentrates on the few years when Munich was a major player in the world of art, showing works by the avant-garde group Der Blaue Reiter

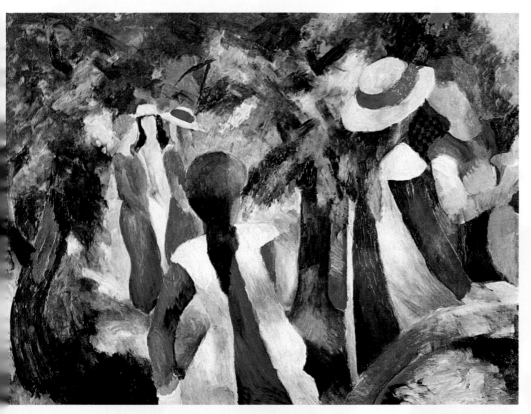

whose members included Wassily Kandinsky, Jean Arp and Paul Klee. Franz von Lenbach, whose magnificent villa is home to the collection, was one of the artistic greats of the late 19th century, as was his colleague Franz von Stuck, who had a stately residence built to his own design on Prinzregentenstraße. Villa Stuck, which has recently been extended and restored, puts on various exhibitions; Stuck's historic rooms can also be visited. The great special exhibitions, which tour the country from city to city, are staged at the Haus der Kunst on Prinzregentenstraße or at the Kunsthalle of the Hypo-Kulturstiftung on Theatinerstraße.

If art isn't your bag, then there's plenty of technology to get to grips with. Here, too, Munich has made something of a name for itself with the Deutsches Museum, built on an island in the River Isar in 1903. At the time of its founding it was revolutionary; here was a museum where you were positively encouraged to touch the exhibits, pushing buttons to make machines work, performing physical experiments and generally adopting a hands-on approach to all kinds of

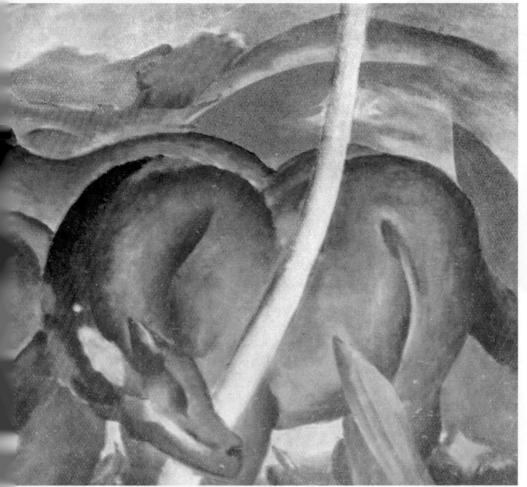

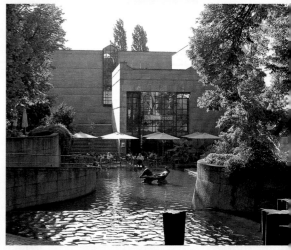

technical marvels. The Deutsches Museum even has a separate transport museum devoted to man and mobility, opened on Theresienhöhe in 2003. If your thirst for all things technological is still not quenched, there are still the BMW-Museum on Petuelring and the SiemensForum on Oskar-von-Miller-Ring. Not forgetting the other 20-odd museums not even mentioned here...

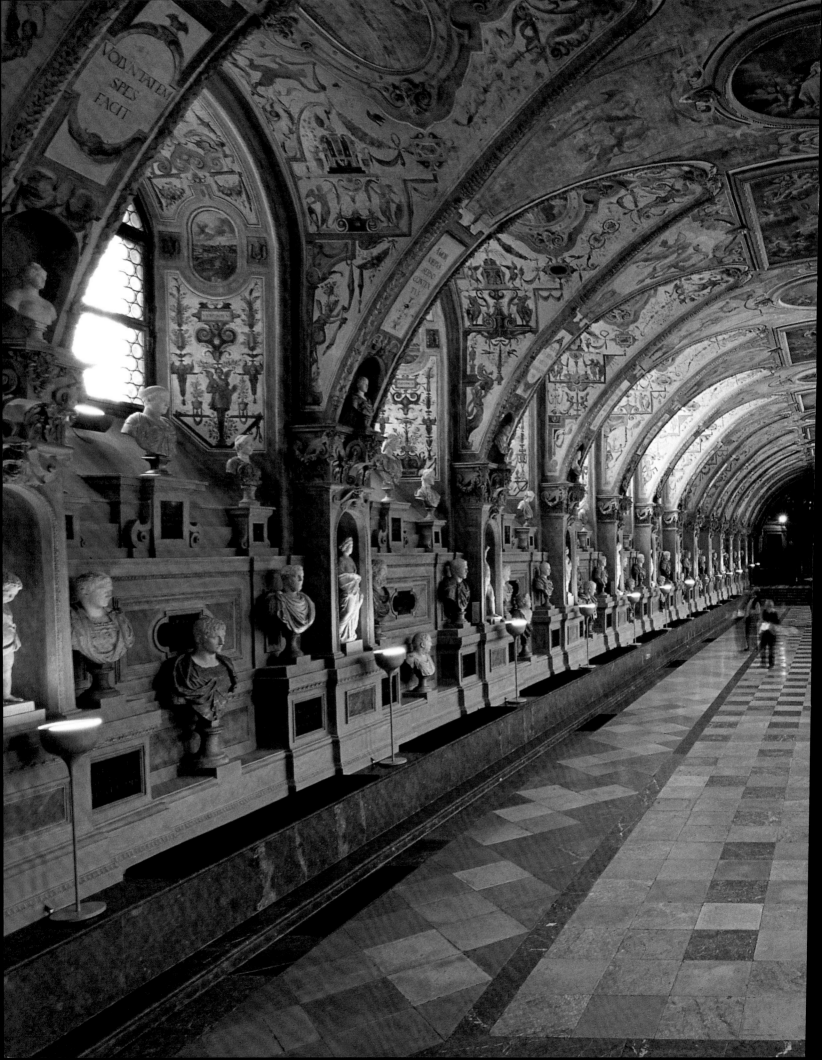

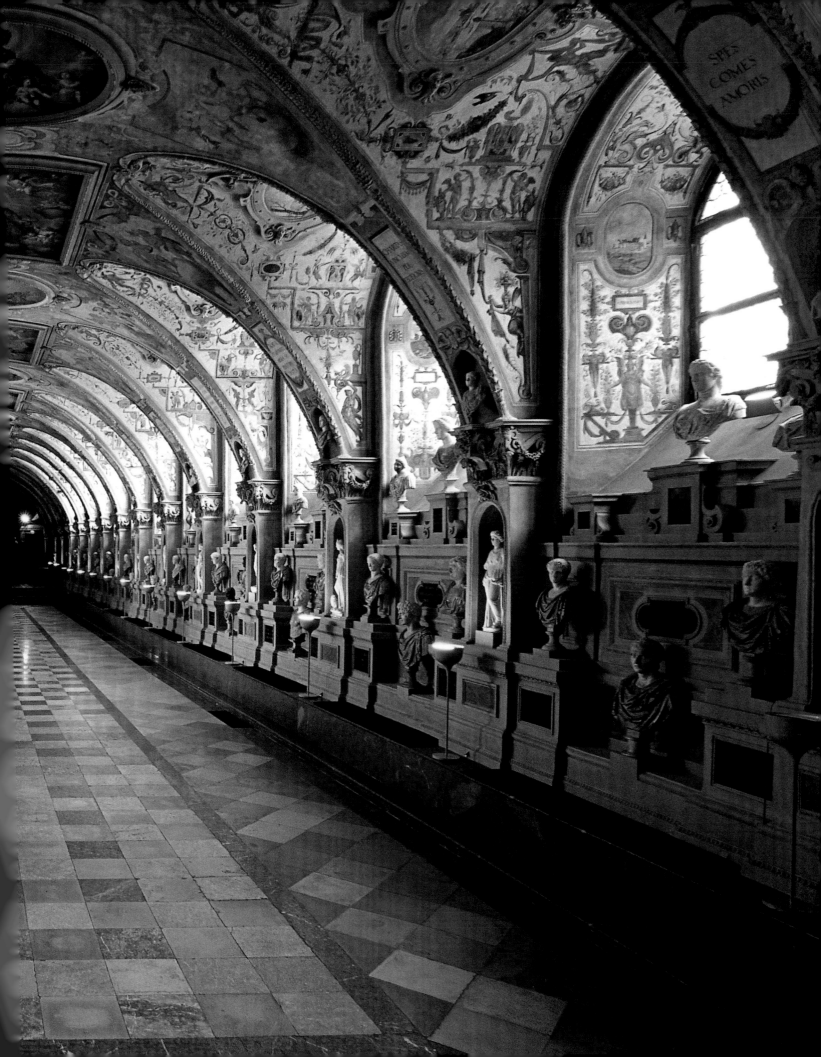

SPES
COMES
AMORIS

Page 54/55:
This magnificent edifice boasts a superlative; the Antiquarium in Munich's royal palace from 1571 is the largest secular Renaissance room north of the Alps.

François de Cuvilliés, the man who in the mid-18th century created one of the most beautiful Rococo theatres in Europe, began his career as a royal dwarf. Later appointed architect to the king, the old royal Cuvilliés-Theater is named after him.

The Brunnenhof of the royal Residenz with the Wittelsbach fountain. The Wittelsbach dynasty lived here until 1918. The building was greatly extended during the 17th and 19th centuries.

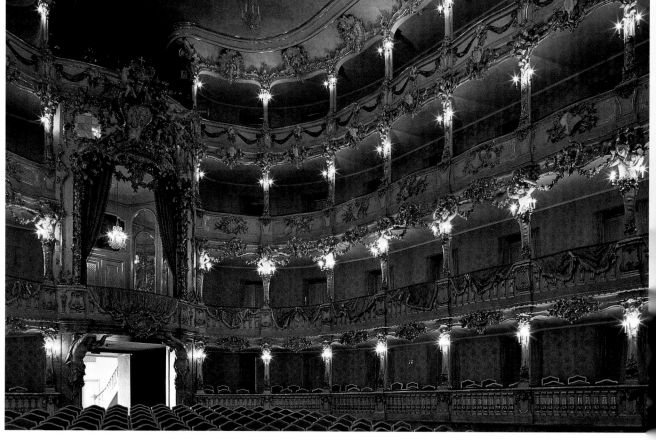

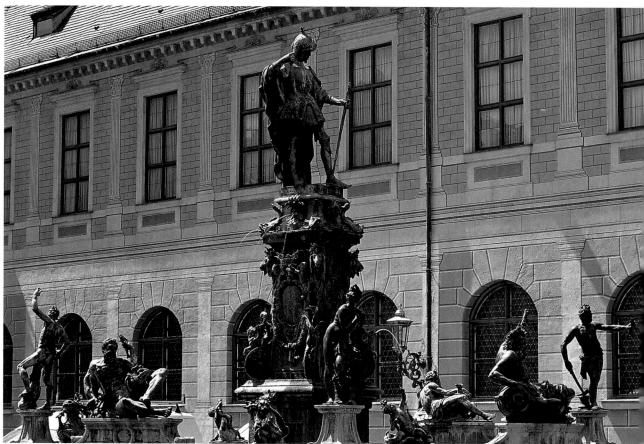

56

The Residenz seen from Max-Joseph-Platz. Leo von Klenze, who built the palace between 1826 and 1835, based his work on the ancient palaces of Florence.

The chambers surrounding the Grottenhof are known as the Reiche Zimmer or rich rooms. They were added after a fire at the royal palace in 1729; here the throne room.

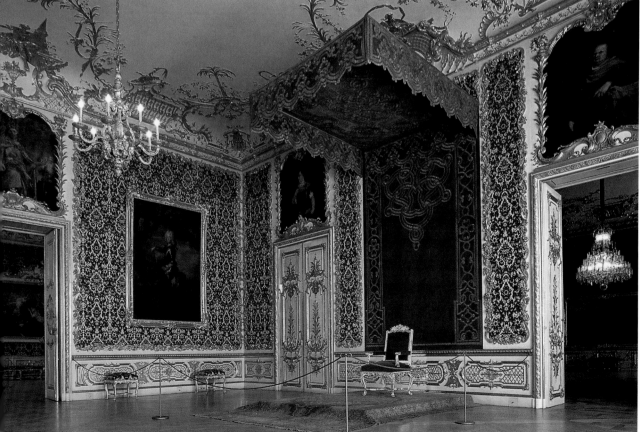

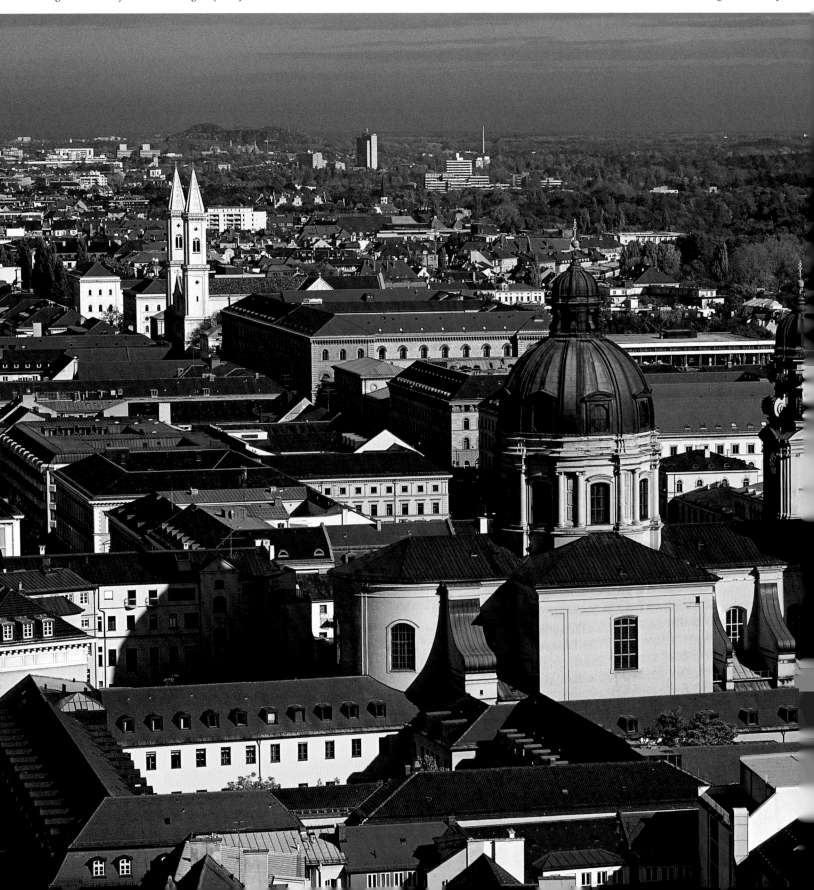

Below:
From the highest build-
ing in the centre of town,
the Frauenkirche, you
have grand views of the

Theatinerkirche, with
the twin white towers of
the Ludwigskirche on
Ludwigstraße beyond it.

Top right:
Standing in front of the
simple, puritanical
facade of the Bürgersaal
on Neuhauser Straße,
the last thing you'd
imagine is this opulent

interior. The church is on the upper floor; the ground floor is dedicated to resistance fighter Father Rupert Mayer who died in 1945.

Centre right:
Looking up into the dome of the Theatinerkirche on Odeonsplatz. It was built in celebration of the birth of Prince Max Emanuel in 1662, the long-awaited heir to the throne.

Bottom right:
The late baroque Damenstiftskirche was furnished by the Asam brothers. The church was badly damaged during the last war but has since been lavishly restored.

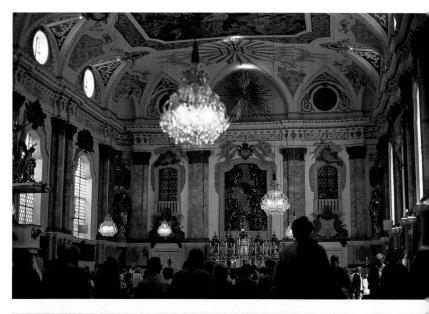

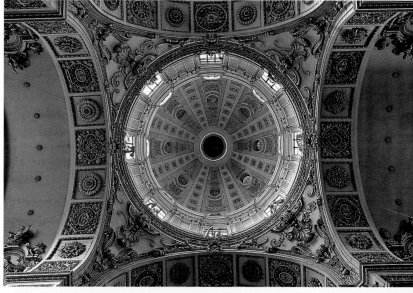

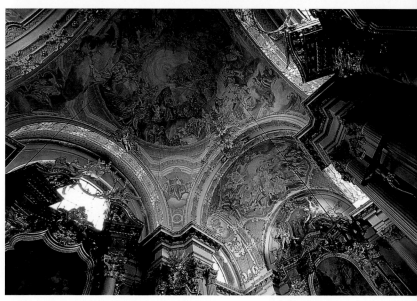

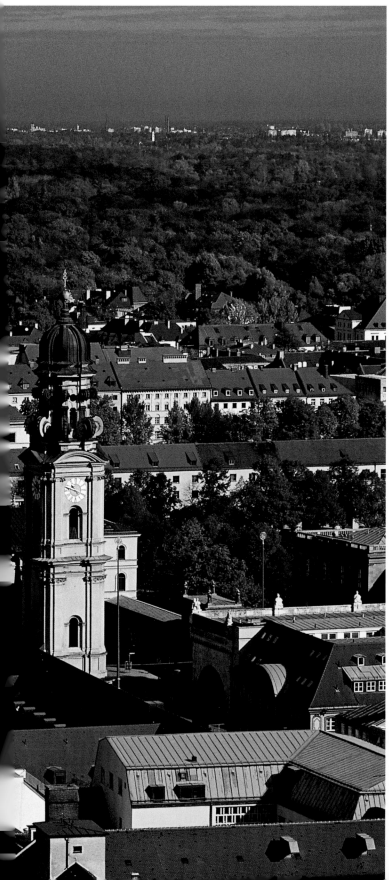

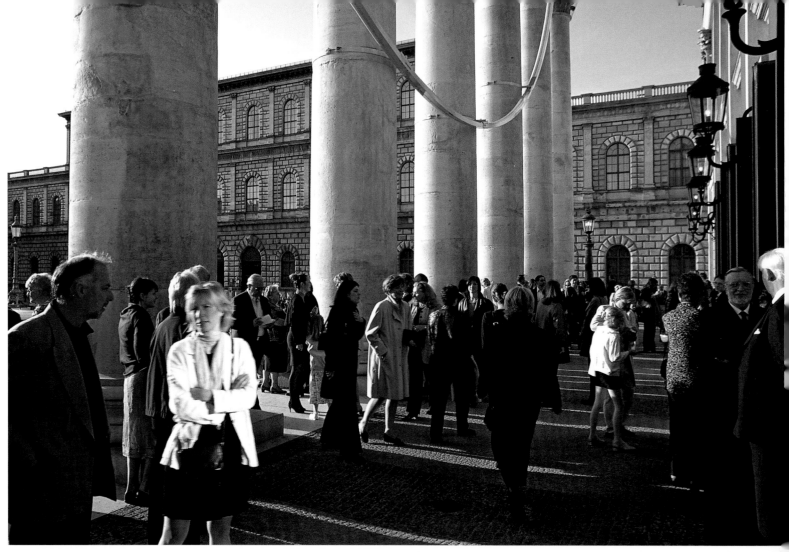

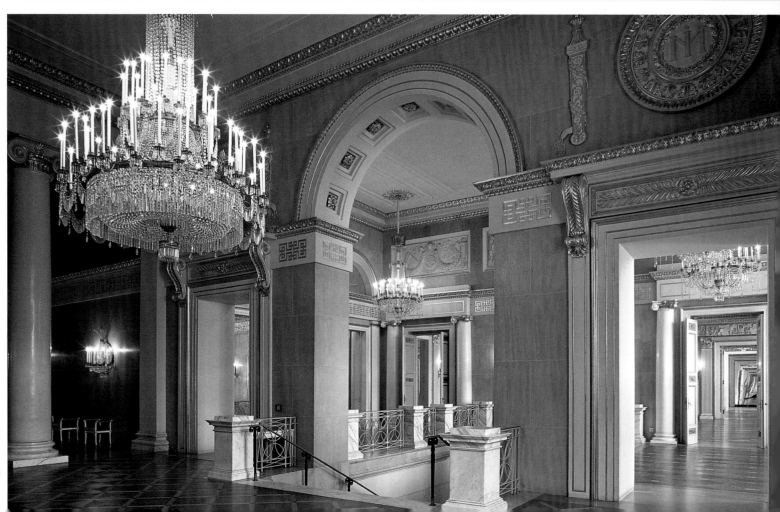

Left:
The arts in Munich are many and varied, one of the main focuses being contemporary art in all its facets. A good, traditional opera, however, never fails to pull the crowds.

Below:
In Munich the name Asam crops up time and again. Here just one of the two brothers, Cosmas Damian Asam, was responsible for the interior of Dreifaltigkeitskirche on Pacellistraße.

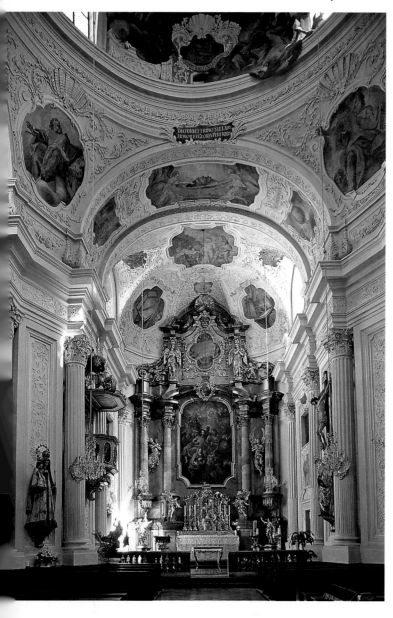

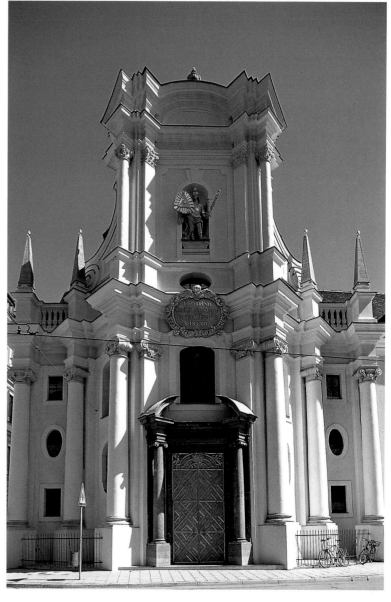

ft:
e interior of the Natio-
ltheater (the opera
use). Destroyed during
Second World War,
rything has since been
uilt as it was during
reign of Munich's
gs.

Above:
The late baroque facade of the Dreifaltigkeits-kirche, completed in 1716 by Giovanni Antonio Viscardi, has an impres-sive array of ornamental pillars.

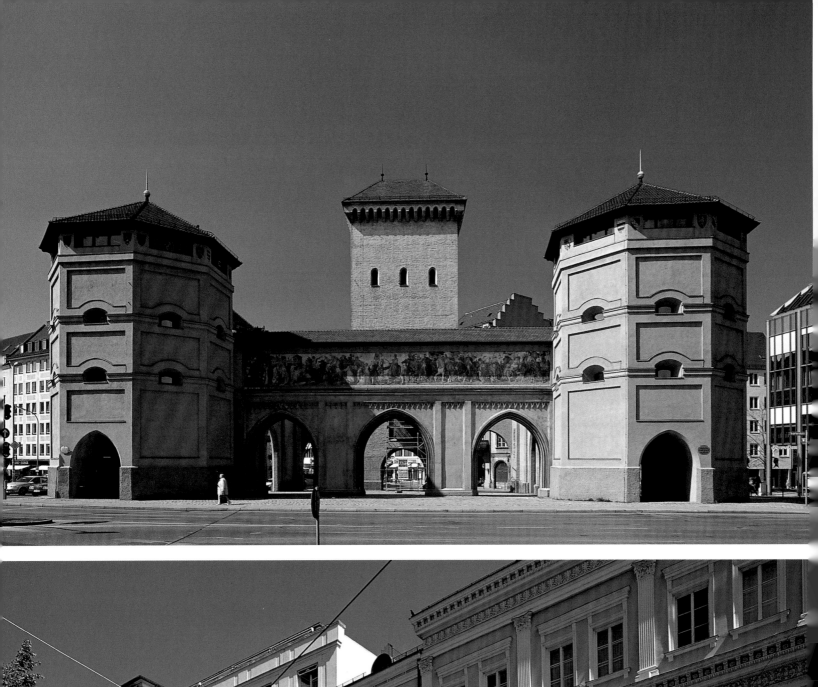

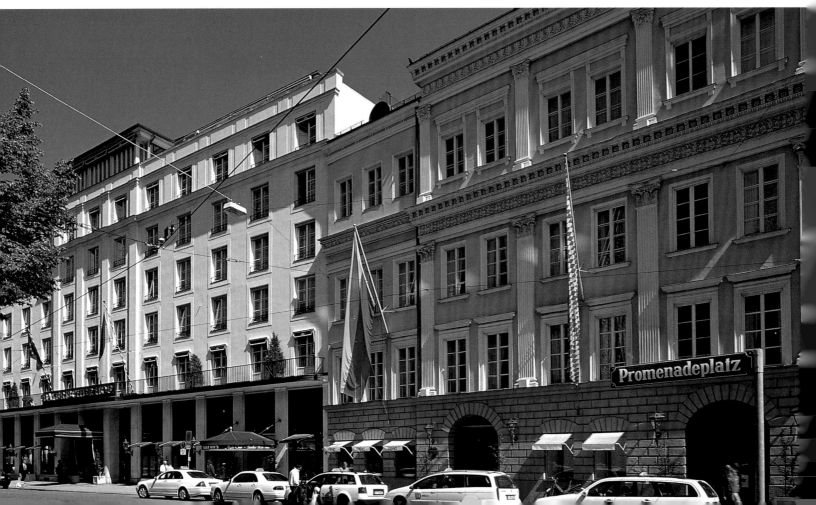

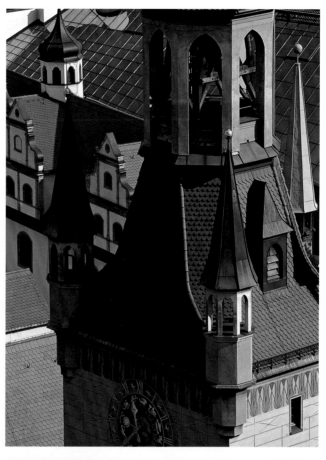

Top left page:
The Isartor is one of the three city gates left standing along the line of the outer city walls which Elector Karl Theodor pulled down on Count Rumford's instructions.

Far left:
Leo von Klenze built the main post office on Max-Joseph-Platz in 1835. Today you can take afternoon coffee in its pillared hall, where frescos adorn deep terra-cotta walls.

Left:
To see the tower of the Neues Rathaus this close up requires a certain amount of effort – namely climbing the 302 steps up to the top of Alter Peter.

Left:
The Theatinerhof is one of the five noble establishments grouped around Theatinerstraße, Weinstraße and Maffeistraße, where you can shop and wine and dine in style.

Bottom left page:
One of the two hotels of tradition in Munich is the Bayerischer Hof on Promenadeplatz. This is where the good and the great reside when they're in town – and any others who can afford it.

Below left and right: *Munich is a city of elegance and a great place for some exclusive shopping. Unusual jewellery is particularly easy to* *come by – although you'll have to dig deep into your pocket for this string of pearls being shown at a Schwabing jeweller's.*

Right: *The upmarket Residenzstraße and Theatinerstraße are joined by a number of* *small arcades, one of the most picturesque being the one under the Preysing-Palais.*

Above: *Konditorei Rottenhöfer on the prestigious* *Residenzstraße is famous for its delicious chocolates.*

Above and right: *One of the most expensive shopping areas is Maximilianstraße between* *Max-Joseph-Platz a the inner city ring ro lined with one exclus boutique after anoth*

Right:
Munich's local comedian
Karl Valentin, who died
in 1948, is so greatly
respected in his home
town that in 1953 a
statue was erected in his
honour on Viktualien-
markt, Munich's colour-
ful all-year market.

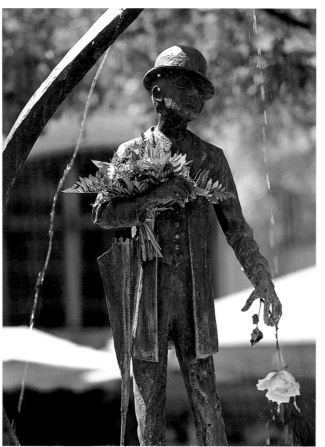

Far right:
The Valentin-Musäum in
the Isartor pays homage
to the great folk singer
and comedian, born in
Munich in 1882.

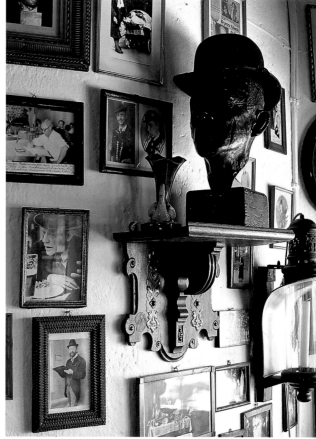

Right:
After visiting the
museum you can climb
the stairs to the top of
the Isartor and enjoy a
drink or two among the
artefacts of the Volks-
sängerlokal.

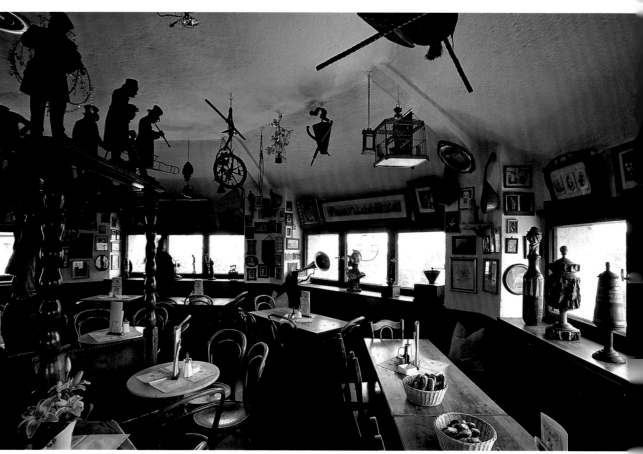

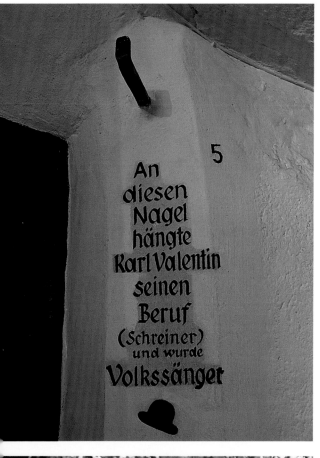

An
diesen
Nagel
hängte
Karl Valentin
seinen
Beruf
(Schreiner)
und wurde
Volkssänger

Far left:
One of the many curiosities exhibited at the museum is the hook Karl Valentin slung as a carpenter. Other oddities include his »nest of unlaid eggs« and a melted snow sculpture.

Left:
Liesl Karlstadt and Karl Valentin made a perfect pair, performing together for 40 years. Liesl naturally has her own place in the museum.

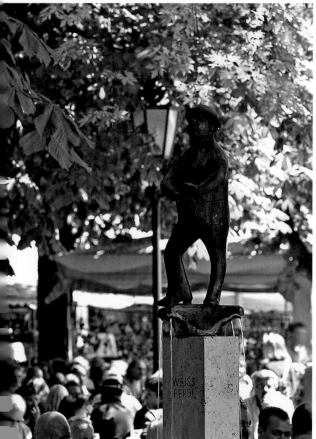

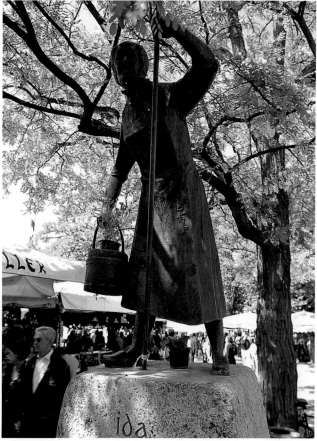

Left and far left:
Viktualienmarkt has several other monuments to Munich comedians famous only among the locals. Weiss Ferdl is one of them and Ida Schuhmacher another, the lady who used to sing a silly song about a woman who polished the city's tram rails.

67

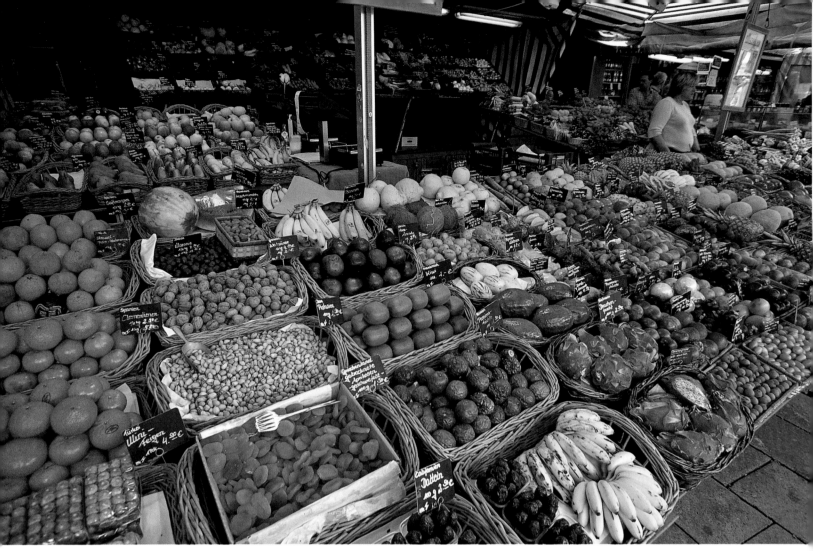

Above:
In the heart of town, just around the corner from Marienplatz, is Munich's Viktualienmarkt, selling local produce and imported goods from all over the world.

Right:
Perusing the delicacies on sale at the market is enough to whet even the smallest appetite – which can then be satisfied at the market food stalls and beer garden.

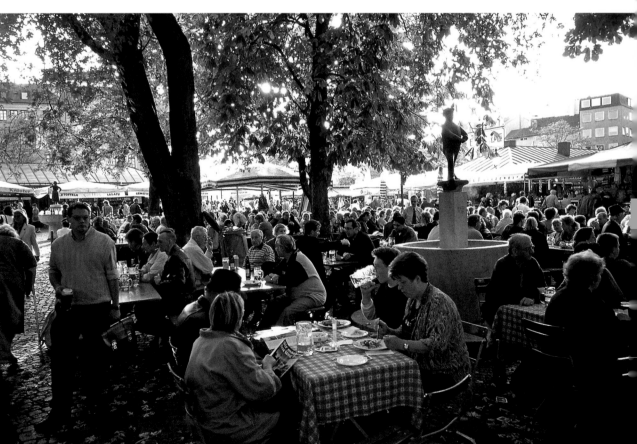

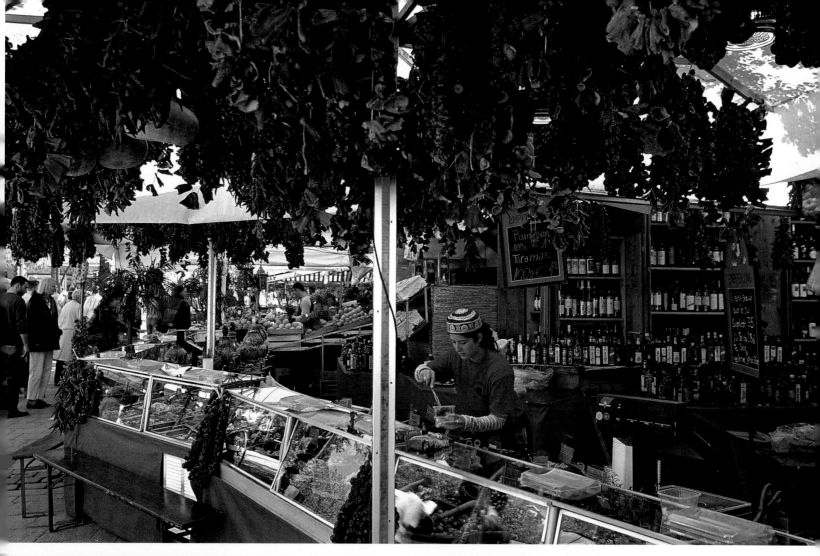

Above:
Both Bavarian speciali-
ties and foreign goods
are popular with visitors
to the Viktualienmarkt.
This trader specialises in
olives, spices and oils
from Greece and Turkey.

Left:
The market sells all
kinds of food and drink
of the highest quality
(here an impressive
selection of cheese and
wine). Be sure to bring
plenty of money with
you; quality comes at a
price ...

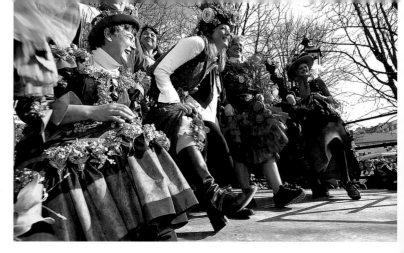

Small photos:
Known elsewhere as Mardi Gras, in Munich the beginning of Lent is called »Fasching«. The highlight is undoubtedly Shrove Tuesday, when the pedestrian zone becomes one huge party of Münchner in fancy dress who bop on down to the Viktualienmarkt to watch traditional dancing and generally drink and be merry.

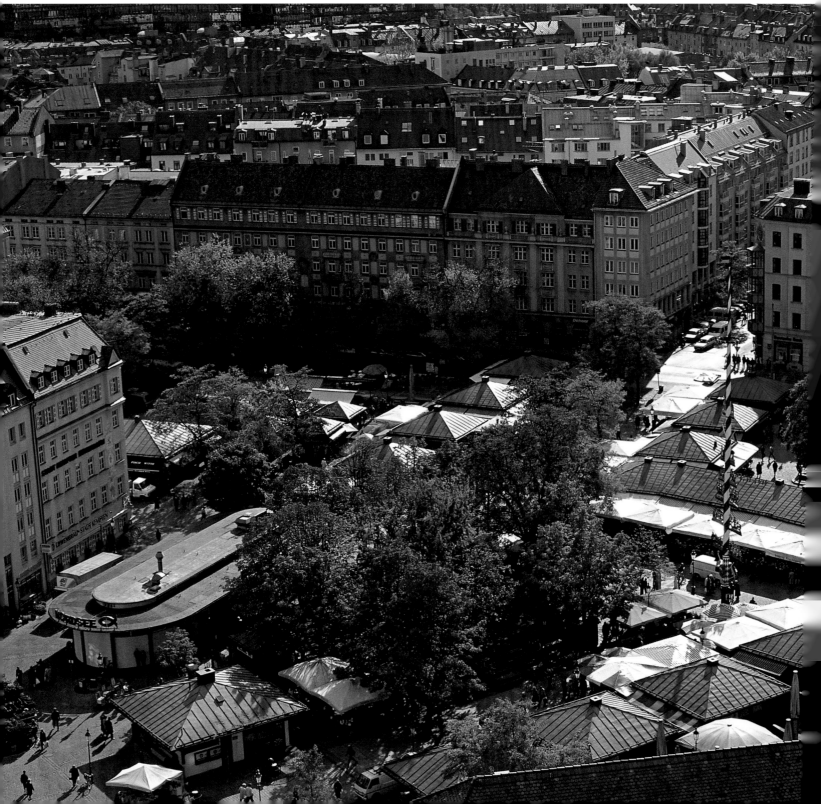

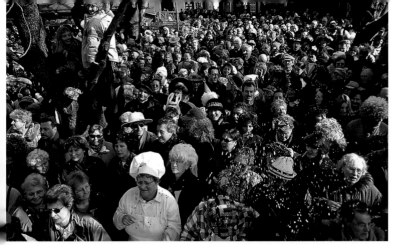

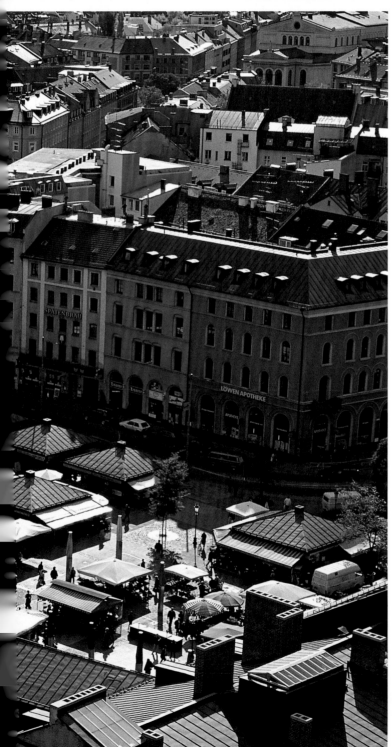

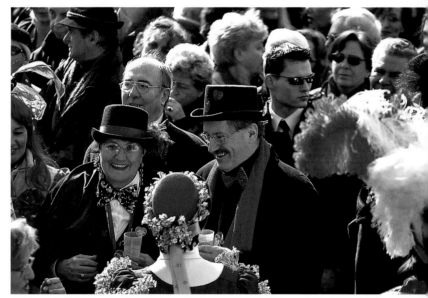

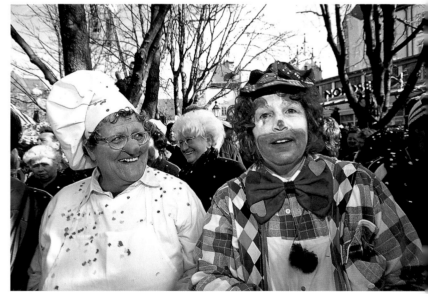

Left:
*Bird's eye view of the
many stands of the
Viktualienmarkt, seen
from the top of Alter
Peter.*

Above centre:
*Even the Lord Mayor
of Munich joins in the
fun at Fasching. This
office has been held by
Christian Ude since
1993.*

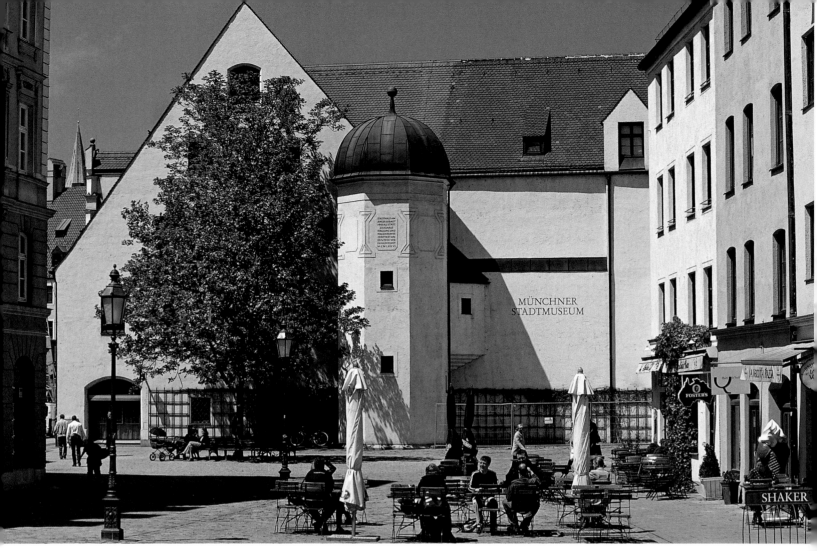

Above:

At the Stadtmuseum on St.-Jakobs-Platz you can study the history of Munich and peruse one of the many popular special exhibitions. The square is currently being redeveloped to make room for the new Jewish Centre with a synagogue and museum, due to open here in 2005.

Right:

When on Residenzstraße it's worth dipping into the courtyards tucked away between the shops. This one, Eilles-Hof at number 13, is a typical covered arcade from the 16th century.

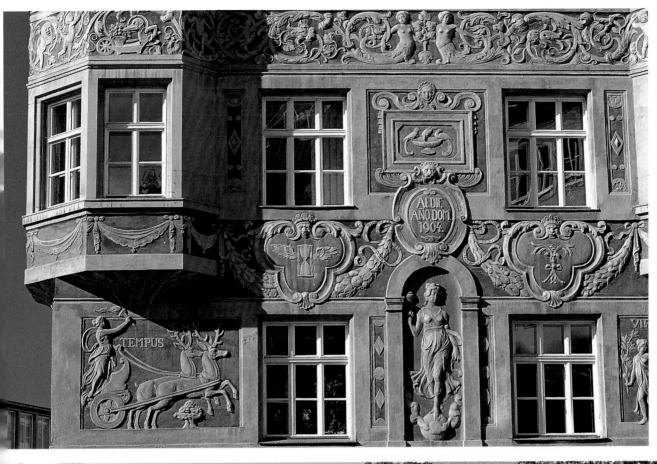

Left:
The Ruffinihäuser on the west corner of Rinder-markt look older than they actually are. These are mock Renaissance from 1904.

Below:
As the name Rinder-markt or cattle market would suggest, this is where livestock was once sold. Today people eat their sandwiches among the bulls – harmless effigies in bronze dotted around a tinkling fountain.

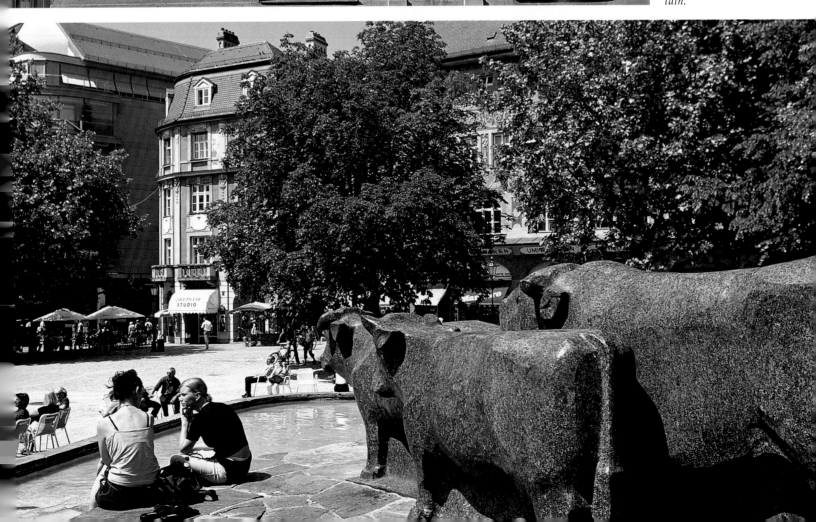

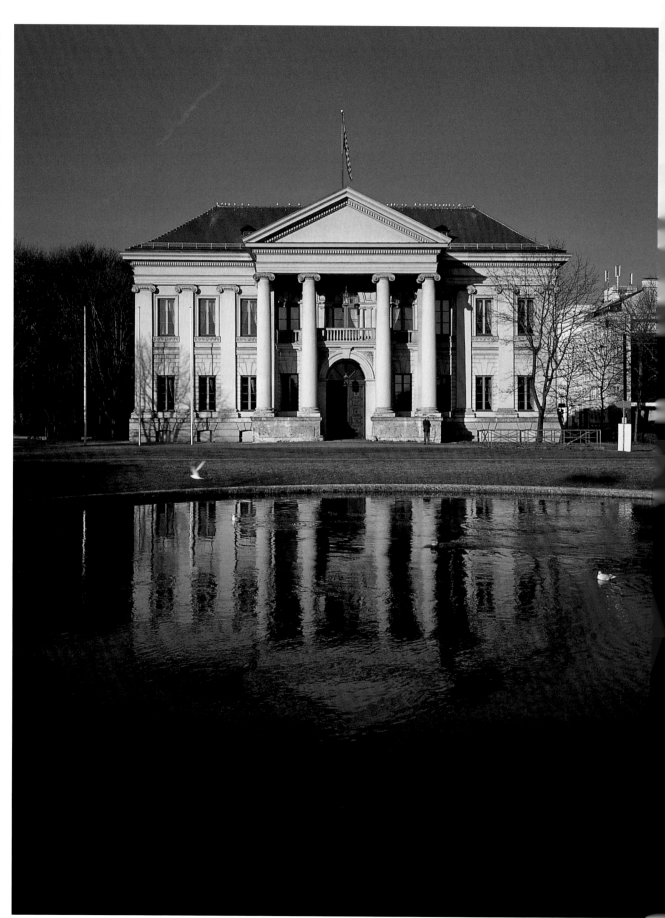

Right:
The Prinz-Carl-Palais on Königinstraße was built between 1804 and 1806 by Karl von Fischer as a focal point at the end of Prinzregentenstraße. An underground tunnel and busy ring road now cut in front of the palace, completely destroying what must have once been a spectacular vista.

Right page:
Those entering the city from the south in the Middle Ages would have passed under the Sendlinger Tor which fortified the 14th-century outer walls with the Karlstor and Isartor. Only the flanking towers of the Sendlinger Tor are originals.

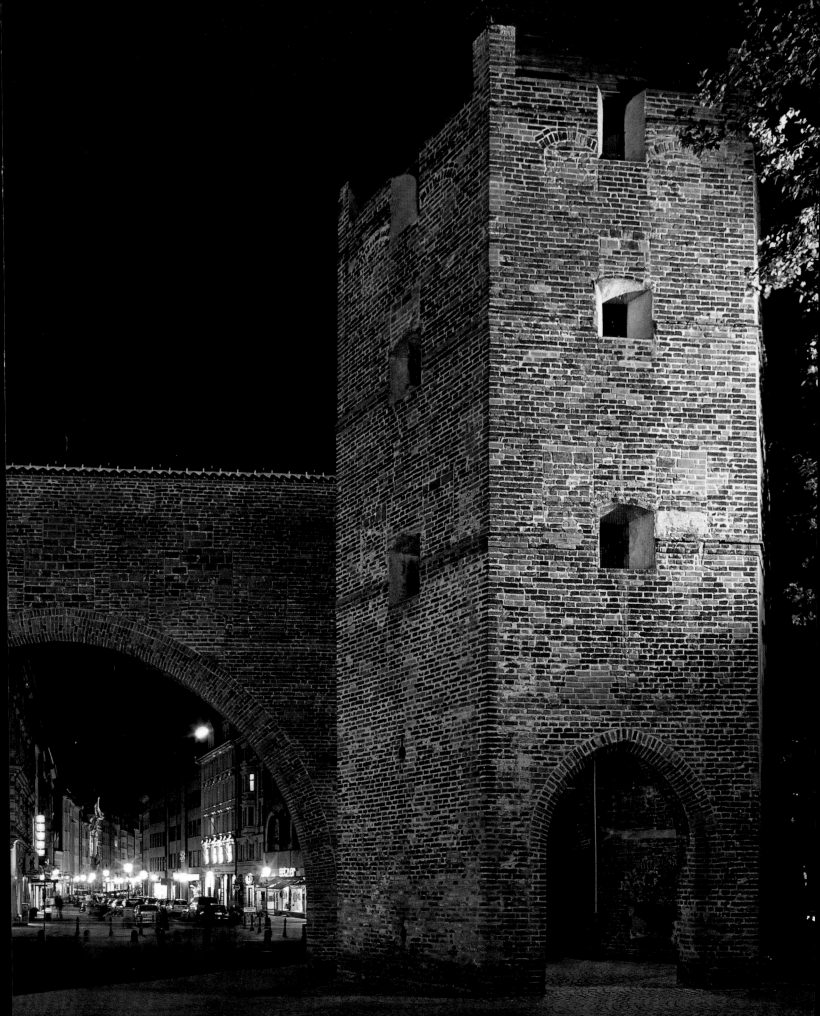

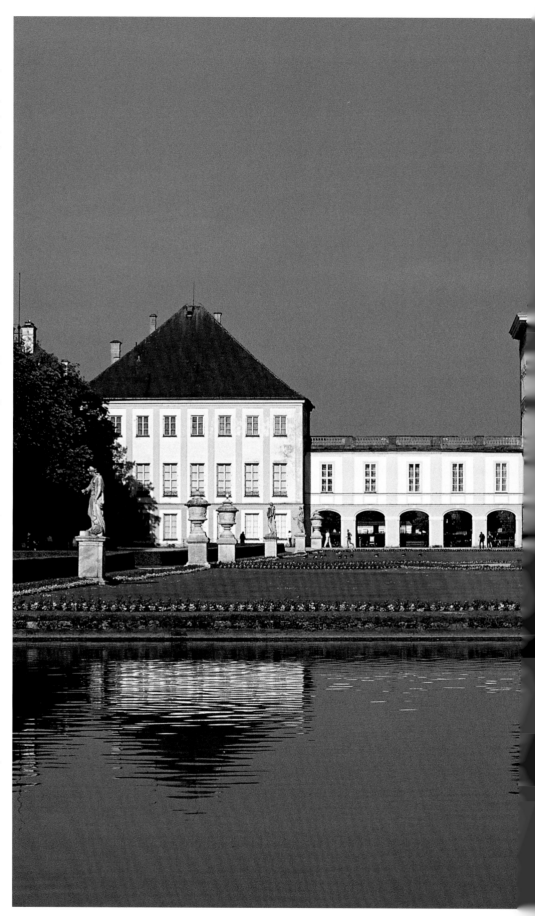

When Ferdinand Maria was blessed with a son in 1662 the elector built his wife a palace in thanks. The heir to the throne later turned it into the magnificent stately residence of Schloss Nymphenburg.

If you want to discover the Munich which lies beyond its famous centre you have to pass through two of the city's gates. The first one – the Isartor – is real. Beyond it are the River Isar and Deutsches Museum. On the other side of the river is the Müllersches Volksbad with its magnificent »Jugendstil« tower, now completely dwarfed by the modern Gasteig arts centre opposite. Walking along the Isar you come to the Maximilianeum from which, via Wiener Platz, you can potter along to Haidhausen with its extremely pleasant Hofbräukeller beer garden. Further along the river and through the park you come to the Friedensengel monument.

Beneath Munich's harbinger of peace the Prinzregentenstraße crosses the Isar and continues on out of town towards Villa Stuck and the Prinzregententheater. North of this street is Bogenhausen, one of Munich's more expensive districts, with its wonderful historic villas. Walking along Prinzregentenstraße back towards the city centre you pass through Lehel with its old town houses lining the edge of the Englischer Garten, where vacant apartments are like gold dust.

The second city gate is a figment of the imagination; the open space where the Schwabinger Tor once stood is now Odeonsplatz. Schwabing itself is still intact, even if the glory of Munich's legendary »fin de siècle« has long faded and the night owls have flown the nest to seek entertainment elsewhere. A stroll along Leopoldstraße is still a must, however, and if you err off the beaten track you'll be rewarded with streets of elegant houses and shady pockets of green.

Munich's modern city gates take you underground to the U- and S-Bahnen with which you can investigate the parts of the city far beyond the medieval walls. There are three major destinations not to be missed in Munich's green belt: the Olympiapark and stadium, Schloss Nymphenburg and the Hellabrunn zoo in Thalkirchen an der Isar.

CITY WALLS

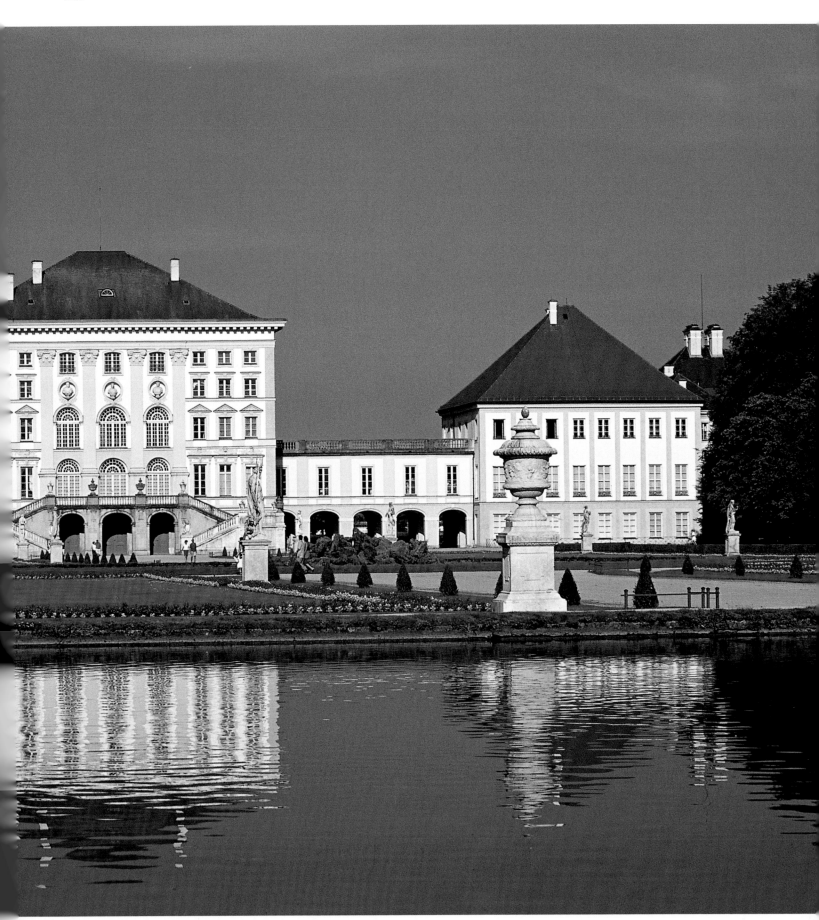

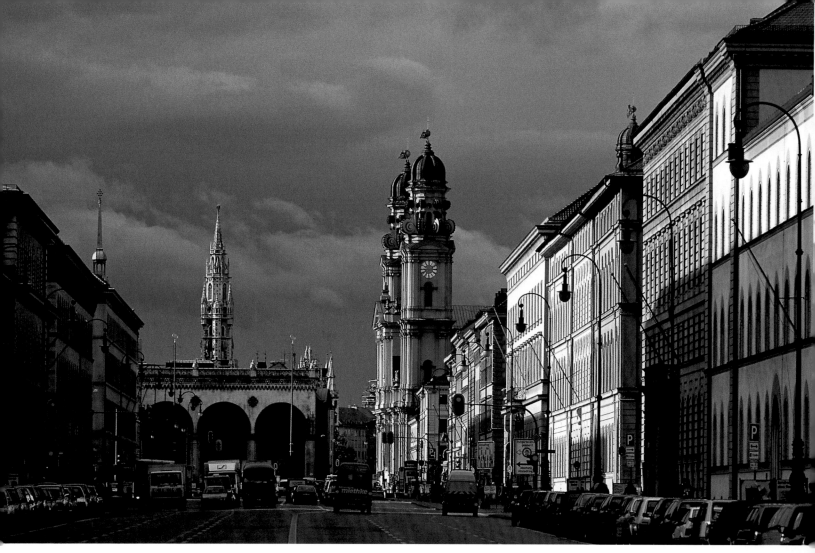

Above:
View of the centre of
town from Ludwigstraße,
with the Theatinerkirche
on the right, the Feld-
herrnhalle on Odeons-
platz and the tower of
the Neues Rathaus in the
background.

Right:
The four great scholars
of the ancient world –
Thucydides, Homer,
Aristotle and Hippocrates
– contemplate industrious
students entering the
Bavarian state library.

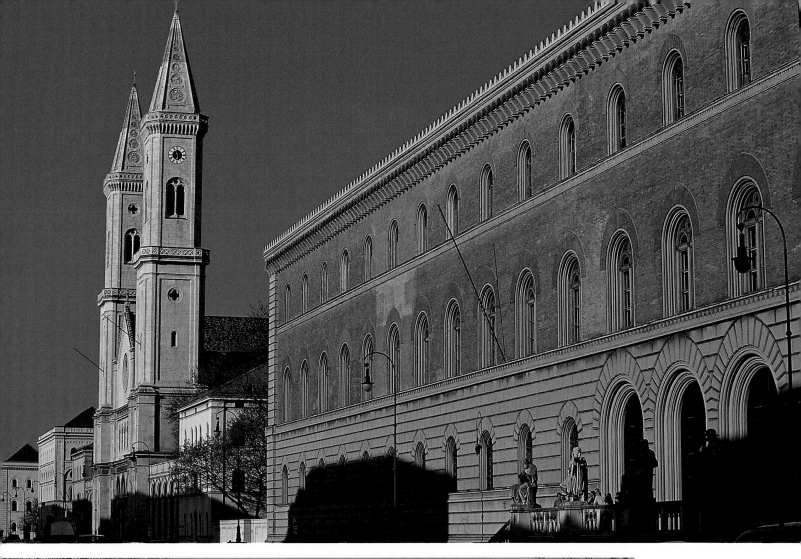

Above:
The state library on Ludwigstraße is the biggest general library in Germany. In the background is the Ludwigskirche.

Left:
The man who made Munich a university town was Ludwig I who in 1826 moved the academic institute, which had been at Ingolstadt since 1472, to his native city. The university fountain stands on Professor-Huber-Platz, the square dedicated to one of the members of the Nazi resistance group The White Rose.

Below:
»Designed for victory, destroyed in war, dedicated to peace« reads the inscription on the Siegestor. These words were added decades after the end of the Second World War when the atrocities of two wars had long deemed facile the 19th-century fashion for triumphal arches heralding the heroics of the Bavarian army.

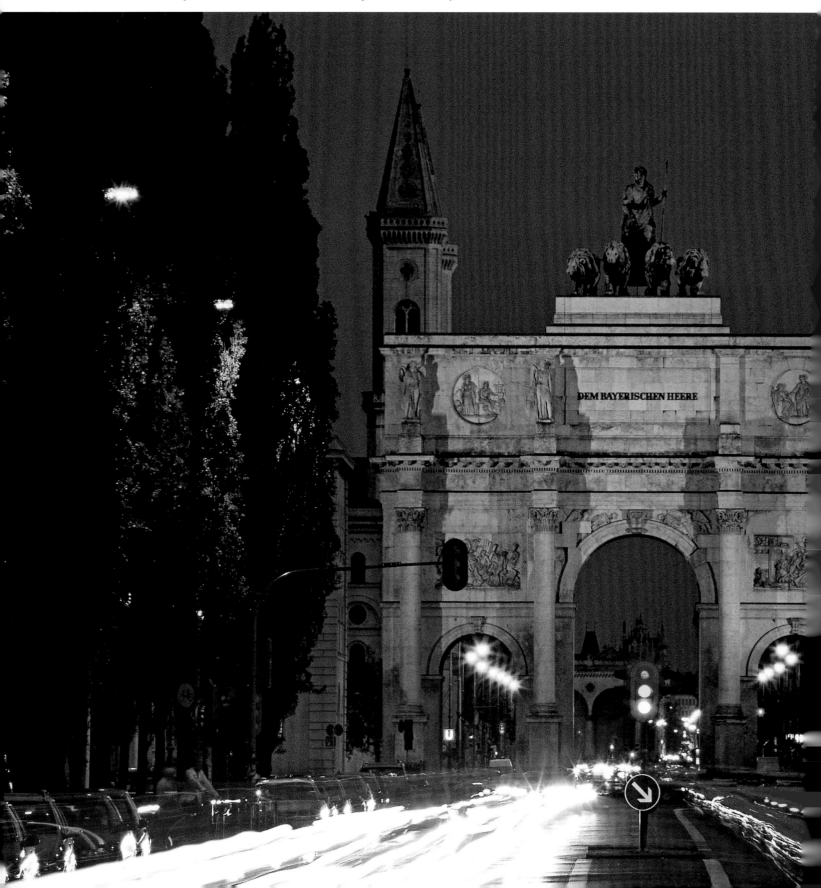

Small photos
on the right:

*Leopoldstraße is the
trendy hub of Schwabing
where in summer the cafés*
*and bars are packed
with Münchner watch-
ing the world go by.*

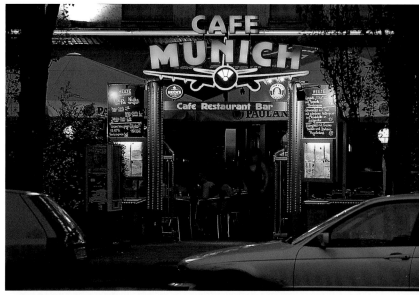

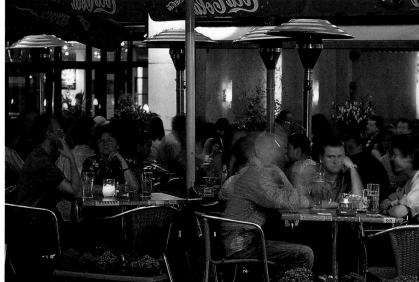

»An intellectual island in the big, wide world« was what Wassily Kandinsky called Schwabing, a district of Munich west of the Englischer Garten. Franziska zu Reventlow, artist, writer and champion of free love, preferred to call it »Wahnmoching« or »the madhouse«. Both are fitting epithets; the Schwabing of the late 19th/early 20th centuries was a mad hive of artistic activity. Artists from all over Europe – painters,

poets, philosophers, women's libbers, cabaret artists and eccentrics of all creeds and colours – were the Bohemians of Schwabing, meeting in private salons and cafés where they held heated discussions and set up magazines and alternative theatres – or simply threw wild and wonderful parties.

Munich pulled the intellectual crowd like no other city in Germany. The spirit of the »belle époch«, the new »joie de vivre« of Parisian provenance, thrived down here in the south, in a city bursting with life and enthusiasm for all things artistic. The grand reputation Munich enjoyed at that time is honoured by none less than Pablo Picasso. In a letter to a friend in 1897 he claimed that if he had a son who wanted to be an artist he would send him nowhere else but Munich.

ROYAL PATRONS, DER BLAUER REITER AND ENTARTETE KUNST

The rise of the royal capital to the metropolis of the European art world was no coincidence. Ludwig I, who came to the throne in 1825, planned to turn his city into a place »which should do Germany credit, [so] that no-one knows Germany without knowing Munich«. The various building projects which he commissioned when he was still crown prince – among them the extension of

the royal palace and the establishing of a number of museums – drew artists and architects to the city in their hundreds. Ludwig I's son, Maximilian II, also saw himself as something of a patron and surrounded himself with literary greats such as Paul Heyse, who was awarded the Nobel Prize for Literature in 1910.

Under the (over)protective auspices of the monarchy, however, few new and original ideas were allowed to thrive; the conservative directors of the art academy, founded in 1808, were also not too keen on having their revered halls littered with radical forms of expression. This only changed in the 1890s when Thomas Mann had just moved to Munich and penned the famous words: »Munich is aglow«. This glow effused from all walks of artistic and intellectual life; in 1892 three Münchner founded the Secession, the pioneering counterpart to the stuffy academy of art which soon, however, became one of the leading institutions in the art world. 1896 saw the launch of the satirical journal »Simplicissimus« and »Jugend« magazine, the latter giving rise to the term »Jugendstil« to describe Germany's »fin-de-siècle« art nouveau. The Mann brothers, Rainer Maria Rilke and Lou Andreas-Salomé, Lion Feuchtwanger and Ernst Toller, Annette Kolb and Franz Wedekind: they and many others all lived and worked on Kandinsky's »intellectual island«, his artistic oasis on the banks of the River Isar.

Yet all was not well on the island. The Munich authorities soon began to voice their displeasure at criticisms expressed by writers such as Erich Mühsam, Oskar Maria Graf and Ernst Toller, for example, who were actively involved in the socialist »Räterepublik« of 1919. The bright young sparks of the cabaret in particular found themselves increasingly plagued by censors and intellectual harassment. Frank Wedekind, who performed at and wrote plays for both Elf Schafrichter and Simpl, two cabarets founded at the beginning of the 20th century, was found so scandalous by the powers that be that he even ended up in prison. At the outbreak of the First World War three Russians – Alexey von Jawlensky, Marianne von Werefkin and Wassily Kandinsky – were also hauled before the authorities who declared them enemy aliens and had them deported. Together with Franz Marc, Gabriele Münter, Paul Klee, Alfred Kubin and August Macke, the three artists were members of Der Blaue Reiter, an avant-garde group formed in 1911 whose influence spread far beyond the confines of Munich.

THE BOHEMIA OF SCHWABING

below:
...opoldstraße always
...uses a busy chic even if
...hwabing is no longer
...e only place to be seen
...out town.

Top right:
Historic facades, such as
these on Habsburger
Platz, are reminiscent of
Schwabing in its heyday,
when here the greats of
literature, art, cabaret,
philosophy and the suffra-
gette movement converged.

Centre right:
On Osterwaldstraße,
right next to the
Englischer Garten, is
the Osterwaldgarten
pub, a popular place
for Sunday brunch.

Bottom right:
Thomas Heine drew the
bulldog featured on the
cover of »Simplicissimus«
whose contributors in-
cluded such writers of
renown as A. Schnitzler,
H. Hesse, F. Wedekind,
H. and Th. Mann.

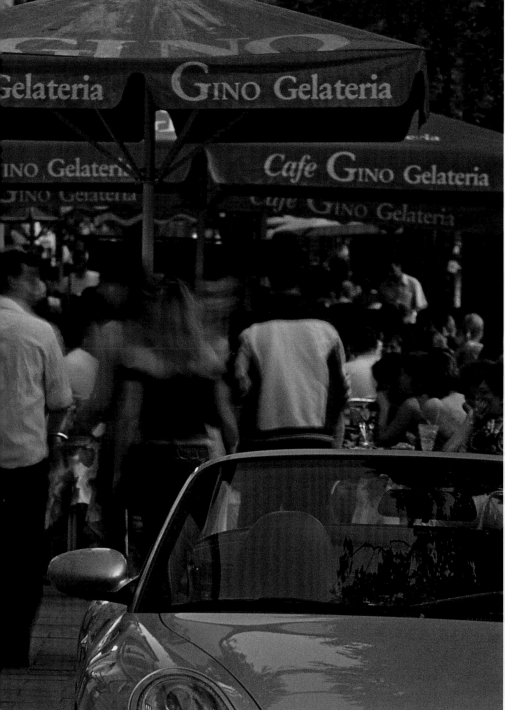

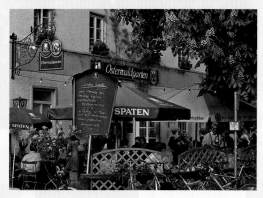

The First World War was the first of the long shadows cast upon the bright intellectual lights of Munich; the arts briefly blossomed once more during the 1920s, only to then finally sink into sorry oblivion in Hitler's bloody rise to power. Many of the city's artists were forced to emigrate; when in 1937 Hitler staged his exhibition of Entartete Kunst the works of those were displayed who just a few decades before had flourished in the easy-going, viva-cious Mediterranean atmosphere of what was now a city under brutal oppression.

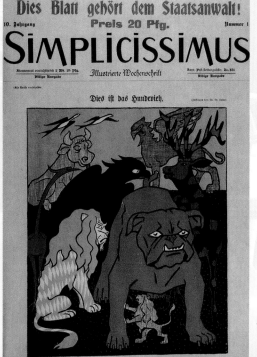

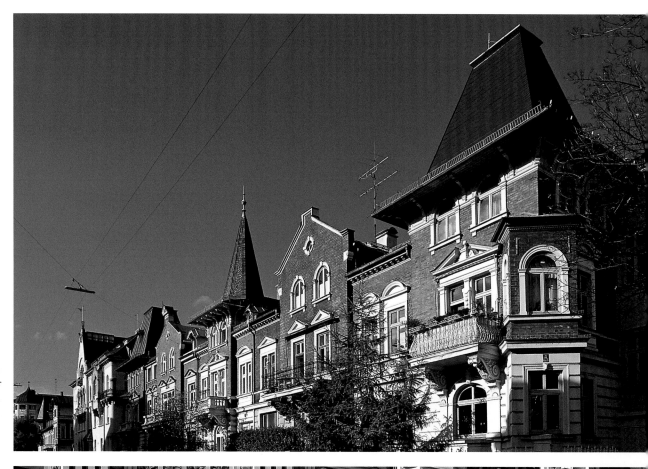

Kaiserstraße in the Munich district of Schwabing with its unusual houses runs from Leopoldstraße to Kaiserplatz.

The term »Jugendstil« (the German equivalent of Art Nouveau) was coined in conjunction with the magazine »Jugend« which was published in Munich at the end of the 19th century. Here a fine Jugendstil house on Ainmillerstraße.

Right page:
Not everyone is enamoured by the Walking Man sculpture on Leopoldstraße, where the end of the 19th century is now forced to converse with the end of the 20th.

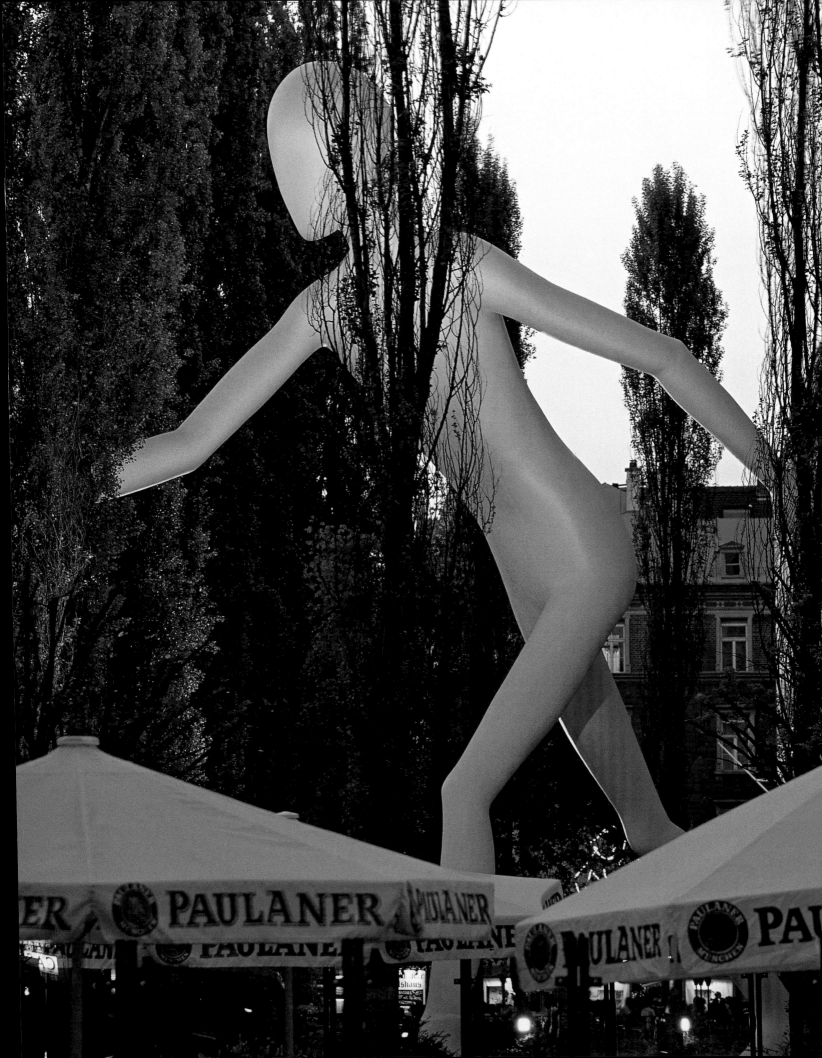

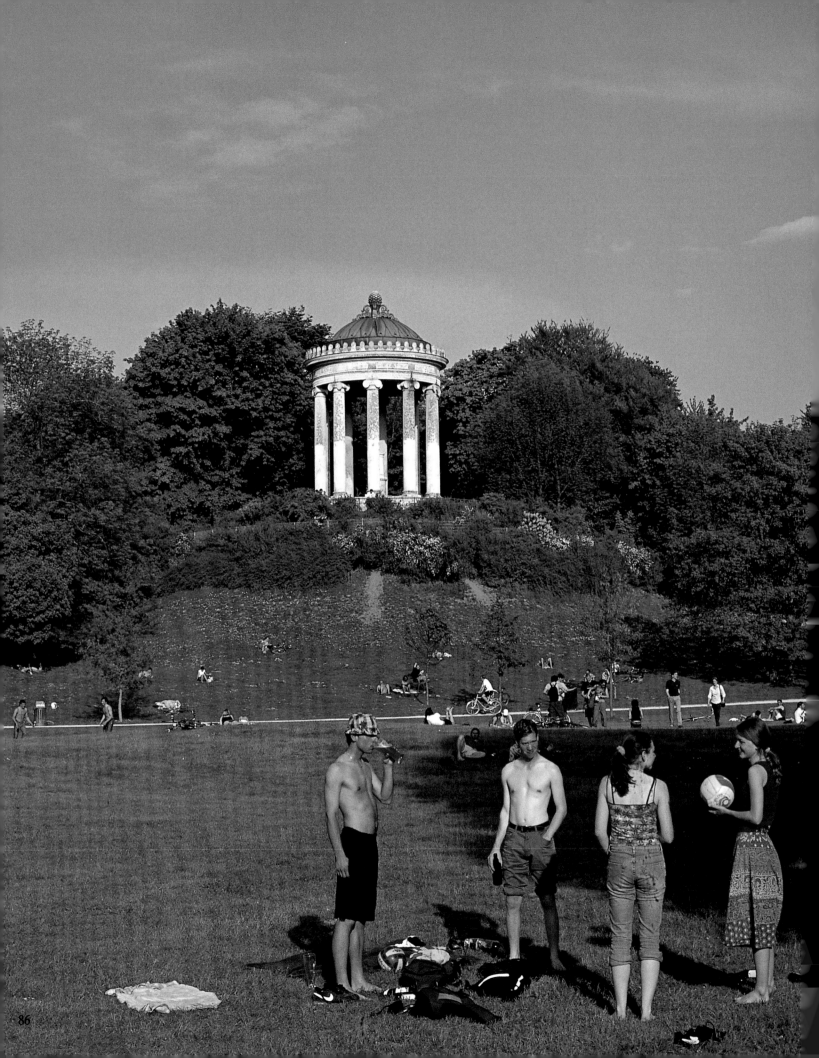

Enjoying the Munich summer beneath the Monopteros, the mock Ancient Greek temple erected in the Englischer Garten during the 19th century.

The further you get from the hustle and bustle of the city centre around Prinzregentenstraße, the quieter the Englischer Garten becomes. It peacefully peters out into the water meadows of the River Isar at Freimann.

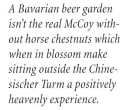

A Bavarian beer garden isn't the real McCoy without horse chestnuts which when in blossom make sitting outside the Chinesischer Turm a positively heavenly experience.

»**W**anderer, stop!« commands the inscription on the base of the statue. »Thanks increases your enjoyment«. The man the casual passer-by is required to offer thanks to is Count Rumford (1753–1814), the father of Munich's Englischer Garten, placed on his pedestal on the corner of Prinzregentenstraße and Lerchenfeldstraße by indebted citizens in 1795/96. Today he's barely visible; way off the beaten track, hidden beneath the trees, his epitaph leads a solitary existence. Those idly meandering through the park have long been usurped by fervent joggers who have neither the time nor the inclination to pause and give thanks to an obscure figure in stone. If they did, they would learn why the man before them was so greatly

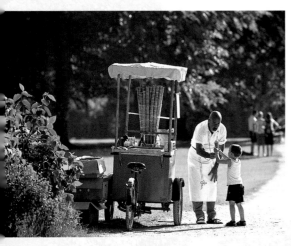

respected by his fellow citizens, so much so that they erected this monument. He was »the people's friend«, it claims. He helped the poor to find employment, banished idleness and begging and founded »a number of educational institutions«.

He also laid out the Englischer Garten, which the people of Munich today see as his main achievement. Rumford's park, not unlike a landscaped English garden, is a huge recreation area with meadows, footpaths, streams, lakes, forest, bridges, statues, follies and beer gardens. Here you can bask in the sun in summer – in some places in your birthday suit – and ski in the winter; children and their pet dogs play on the grass, cyclists and joggers exercise their supple limbs; and perhaps the distant relatives of Rumford's »wanderer« can be found lazily supping a beer or two under the shady canopies at the Chinesischer Turm, looking out across the lake at the Seehaus or relaxing on the benches outside Aumeister in the north.

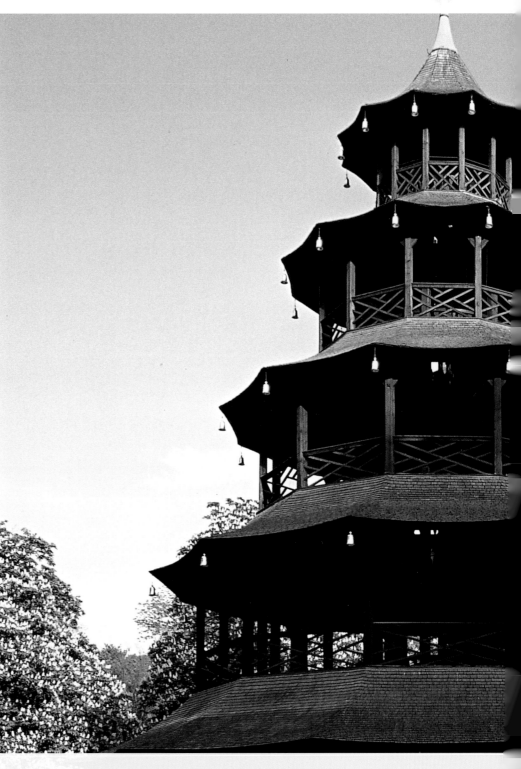

Top left:
On hot days ice-cream sellers make a fortune in the Englischer Garten.

Above:
The Chinese tower in the Englischer Garten was originally built as a viewing platform and music pagoda in 1789/90 in keeping with the 18th-century trend for all things exotic.

Small picture top right
After jogging round the Kleinhesseloher See you can take a breather the Seehaus beer garden – at a table right on the water's edge, if you lucky (lef

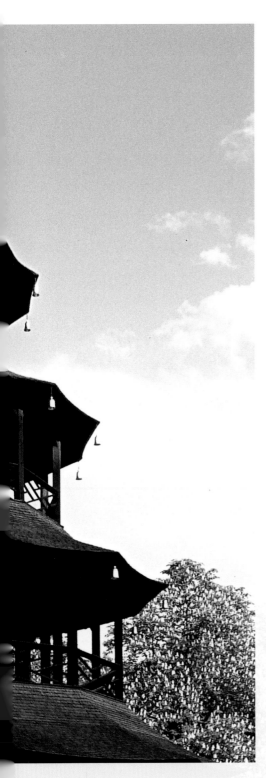

A MAN OF MANY TALENTS: SPY, DIPLOMAT, SCIENTIST AND SOCIAL REFORMER

The Englischer Garten was opened in 1789 as a public park yet the man who created it had more than just the recreation of the citizens of Munich in mind. This was a project with a definite purpose. Rumford was an educationalist who wanted to teach and »ennoble« people; he was a fierce advocate of the then revolutionary idea that

Rumford quickly realised that this was a problem which called for immediate reform and set about tackling it from all angles. He provided decent accommodation, schools and hospitals for the soldiers and their families; he made sure there was enough cheap, nutritious food to eat, inventing not just his famous Rumford soup but also the concept of the canteen and kitchen ranges which could cater for huge numbers. He provided beggars with shelter, work and education and kept soldiers not needed in combat busy with purposeful activities; each was given a small plot of land and seed and taught to

people could only improve if their general standard of living was improved. »One generally assumes that the depraved and the degenerate must first be made virtuous before they can be content. Why should one not dare to attempt this in reverse? Why not first be content and then virtuous?«

True to his motto Rumford, himself ennobled by Bavarian elector Karl Theodor with more power and office than his courtiers and magistrate would have liked, set about introducing his reforms. Karl Theodor initially commissioned the American, who had made a name for himself as a scientist and at the court in London, to reform the army which was in a desperate state. The soldiers were badly paid, undernourished and poorly dressed. In times of peace they were redundant, idleness and hunger driving them to beg and steal their way across the country. Many of them plagued the cities as vagrants and vagabonds, despised by the more fortunate – in Munich in particular.

grow, among other things, potatoes, which Rumford first introduced to Bavaria. These allotments formed the basis of the Englischer Garten which also had open farms and a school of veterinary medicine which in turn were intended to educate the people and improve local agriculture.

Rumford was a difficult man; he was vain and keen to seize any opportunity to better his own social standing – often to his own financial advantage. During the American Revolution he had worked as a spy for the British and wherever he travelled in Europe he made more enemies than friends. He even eventually left Munich in 1798, tired of the intrigue and endless disputes. Munich's courtiers and magistrate hated the »foreigner« who acted as if he was the sole ruler of the city, yet the people adored him. He had given them something far more important than the Englischer Garten we know and love today – hope, self-esteem and a chance to better themselves.

he Eisbach is one of the ·any streams and rivers ·hich have been covered over in the city centre and only re-emerge on the far side of Prinzregentenstraße in the Englischer Garten (centre).

The Englischer Garten is a green oasis in the heart of the city – but so popular in summer that finding a solitary spot can prove difficult (right).

Right:
In this picture from 1898 the Kleinhesseloher See in the Englischer Garten seems even more idyllic than it is today.

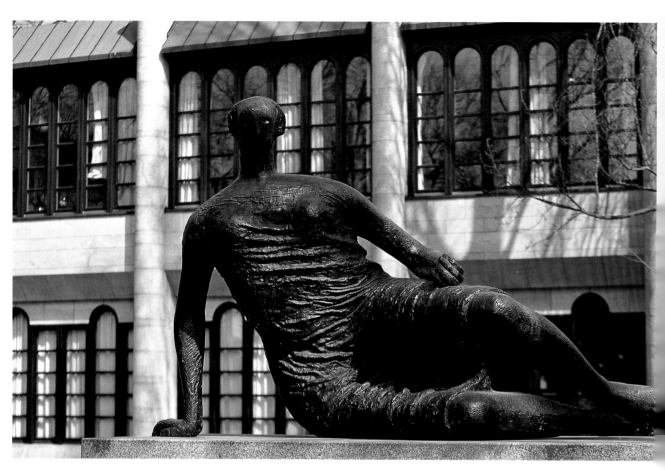

Right:
Outside Munich's Neue Pinakothek a 20th-century statue by Henry Moore gracefully reclines.

Below:
Sculptures, reliefs and carvings, the grand masterpieces of the Ancient World, are on display at the Glyptothek on Königsplatz.

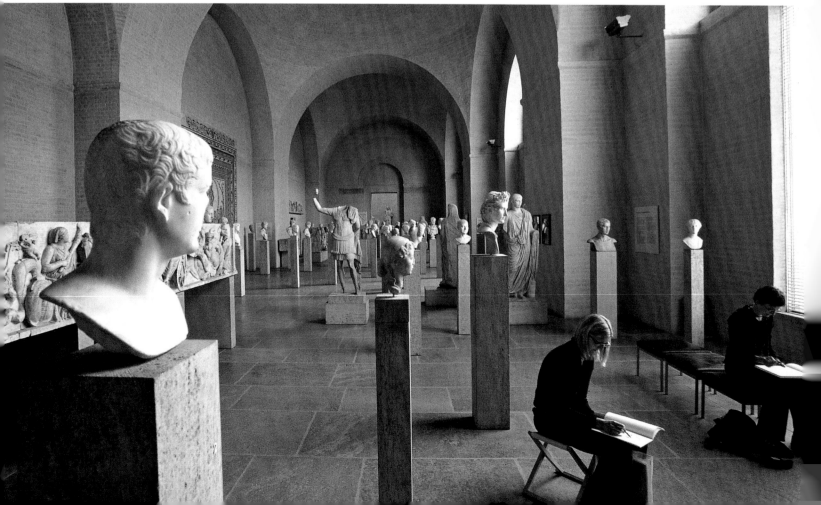

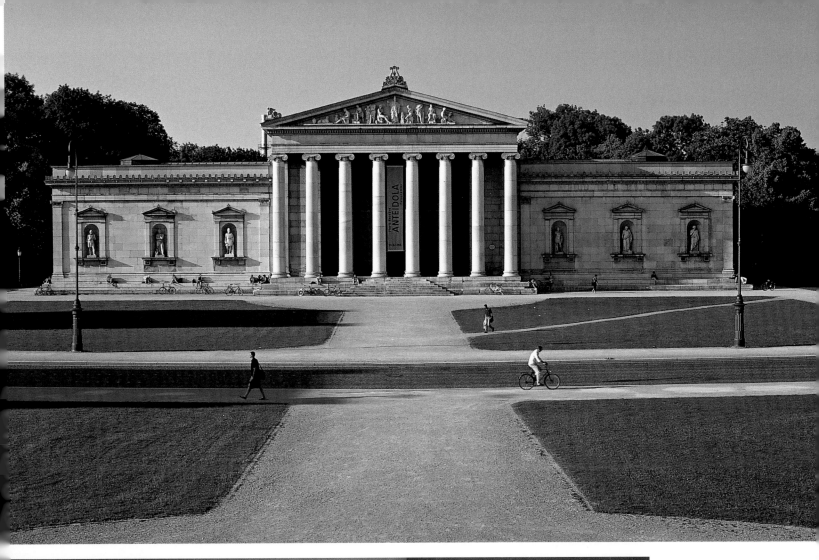

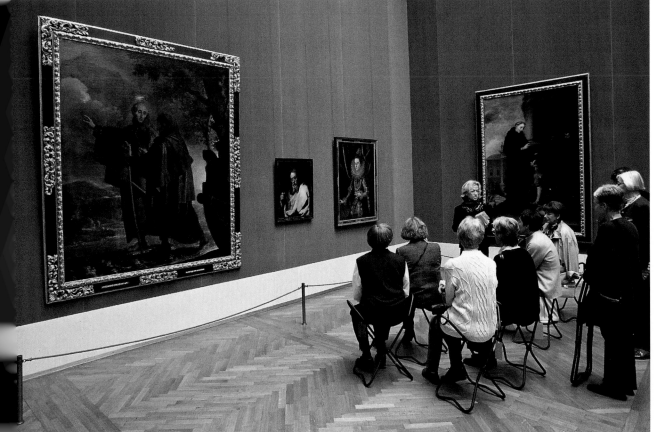

Above:
Königsplatz, here with the Glyptothek, was a parade ground during the Third Reich. The original lawn design was reintroduced in 1988.

Left:
The Alte Pinakothek is one of the largest collections of paintings in the world. The gallery has an impressive number of Old Masters dating from the Middle Ages to the early 19th century.

91

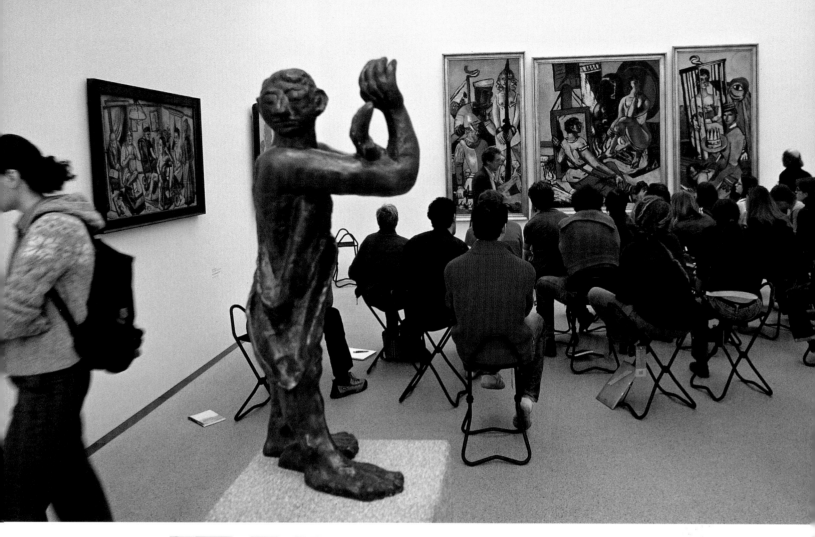

Above:
With the opening of the Pinakothek der Moderne in 2002 Munich finally established itself as a major centre of art. The galleries along Barer-straße now make up a collection of works which span all genres, periods and styles.

Right:
Munich architect Stefan von Braunfels's design for the new Pinakothek der Moderne has earned him praise on all sides.

Above:
The exterior of the Pina-
kothek der Moderne,
which shortly after its
opening clocked up
record numbers of visi-
tors who had come to
admire the paintings,
sculptures, photographs,
video installations and
computer animations.

Left:
The design section, one
of the four themed areas
of the Pinakothek der
Moderne which also
include art, graphics and
architecture. The classic
artists of the Modern
Age are also on show,
among them Beckmann,
Klee and Picasso.

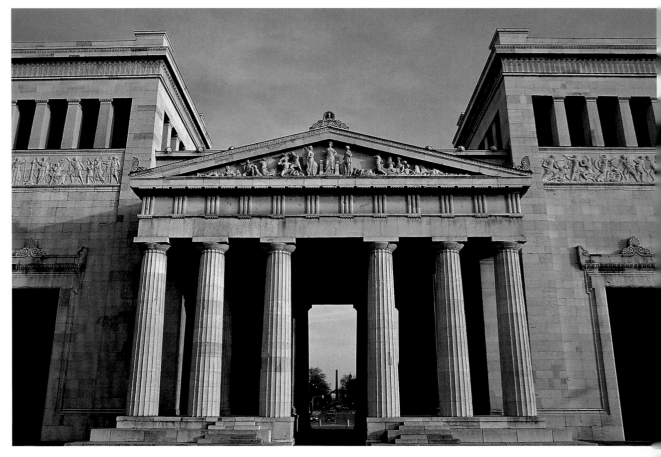

In Königsplatz Ludwig I and his architect Leo von Klenze have created a wonderful architectural ensemble consisting of Munich's propylaea, Glyptothek and collection of antiquities.

This fantastical 19th-century model of Jerusalem is one of the treasures on display at Bavaria's national museum which is also famous for its collection of Christmas cribs.

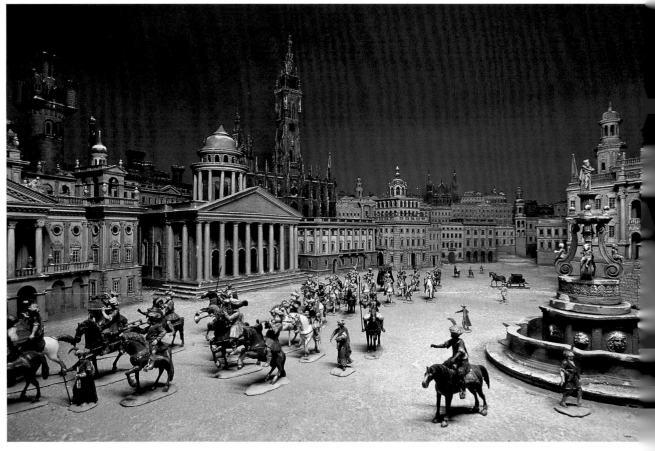

A manifestation of the architectural trend for all things historical, the Bayerisches National-museum on Prinzregen-tenstraße was erected by royal architect Gabriel von Seidl between 1894 and 1899.

Far left:
These leaflets set into the pavement on Geschwister-Scholl-Platz are a very special monument to The White Rose, a group of students and professors at Munich university who protested against the Hitler regime and paid for their bravery with their lives.

Left:
The Haus der Kunst on Prinzregentenstraße is a pompous remnant of the Third Reich. Today international exhibitions are staged here.

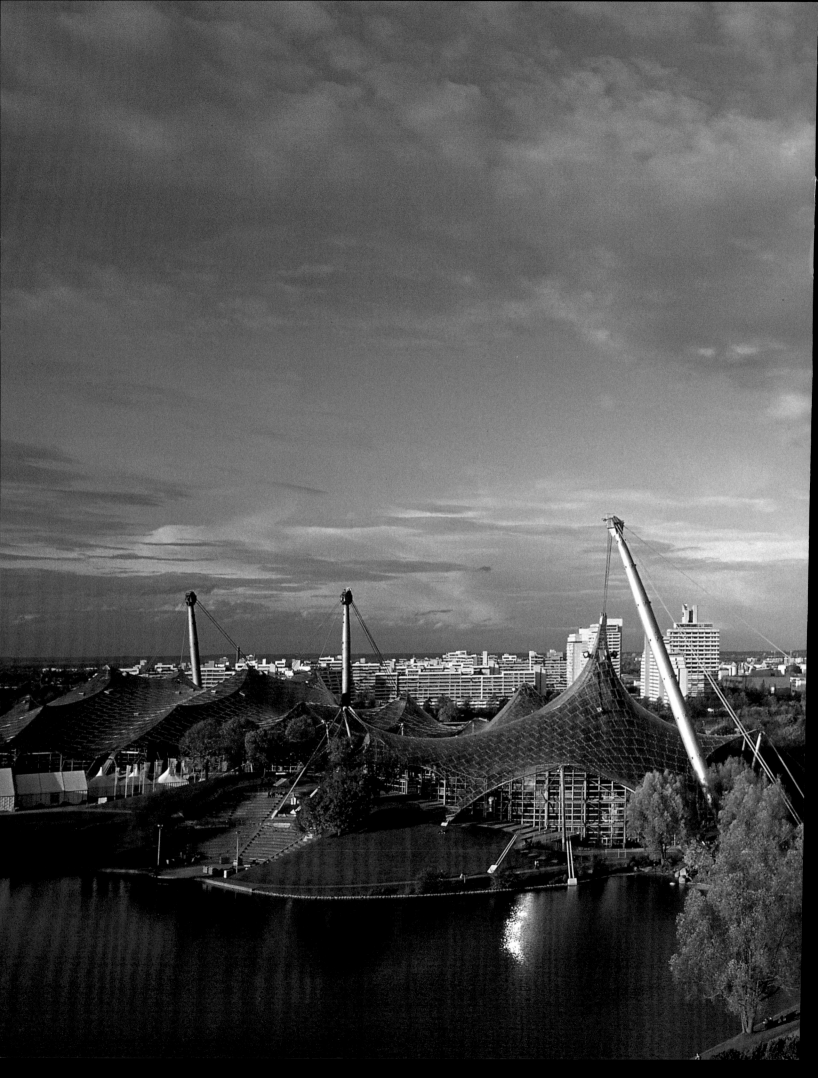

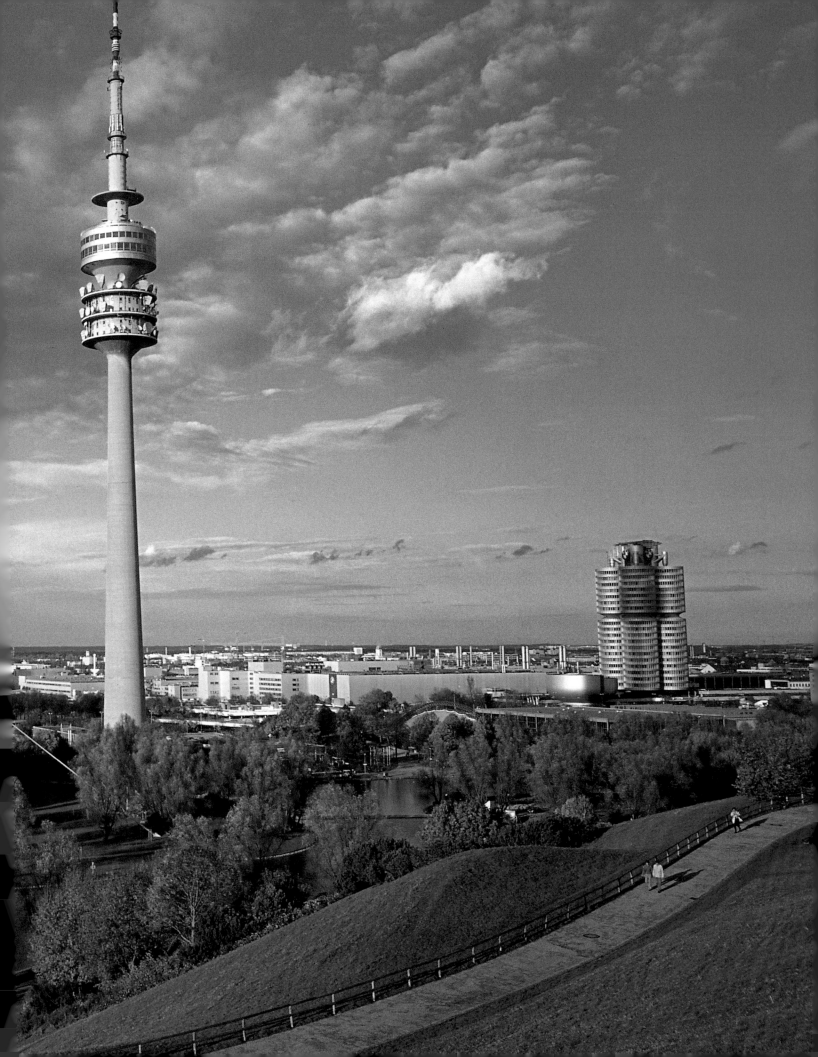

Page 96/97:
In 1972 Munich was the venue of the Summer Olympics. The stadium, with its futuristic tent roof of steel netting and acrylic glass, is still used for major sporting events. There are fantastic views out across Munich and the surrounding area from the top of the Olympiaturm.

Below:
Swans, ducks and geese enjoying the water in the park of Schloss Nymphenburg.

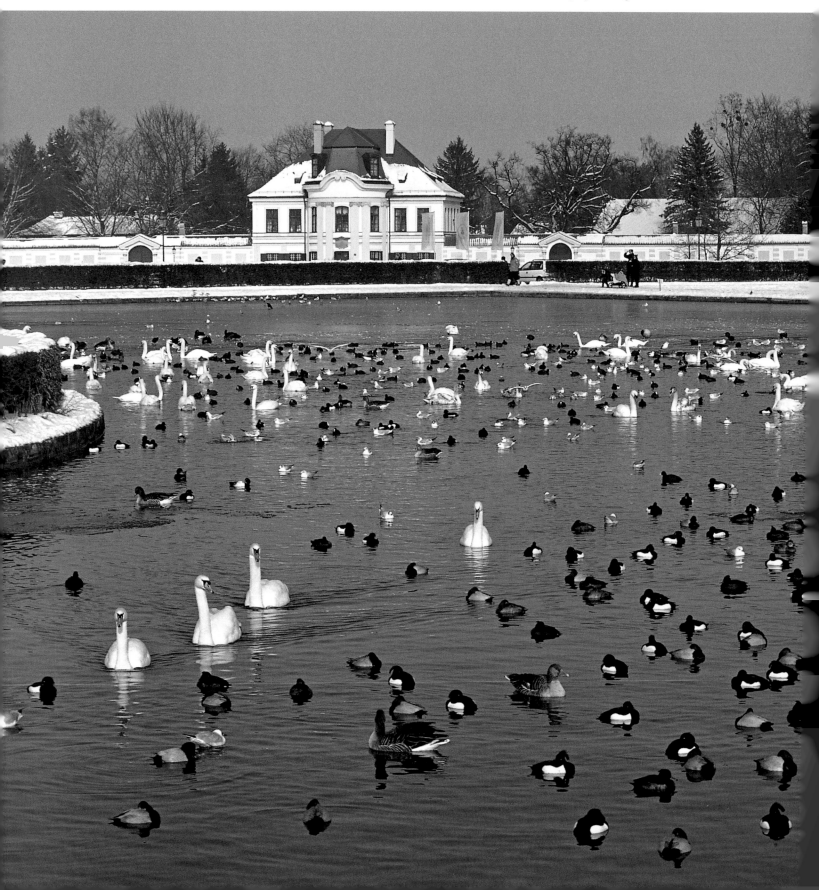

Top right:
When the canal running into the park at Schloss Nymphenburg freezes over, curlers take to the ice.

Centre right:
Skating on a frozen lake against the backdrop of Schloss Nymphenburg is one of many pleasures of winter in Munich.

Bottom right:
Even the swans stick around for Munich's winters, with plenty of sympathetic souls ready to feed them when the temperature drops.

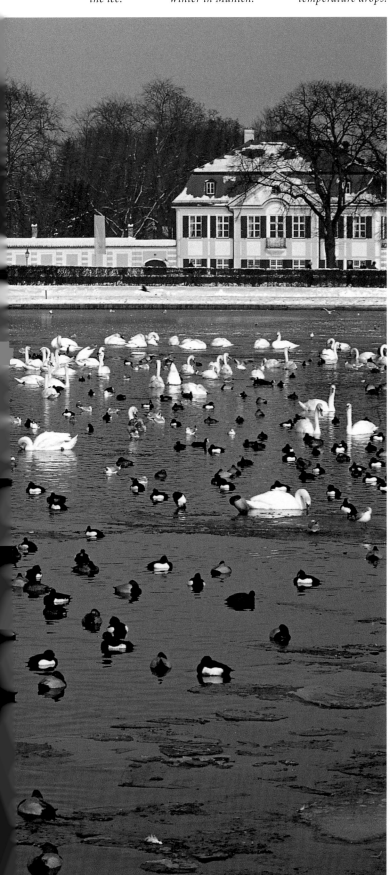

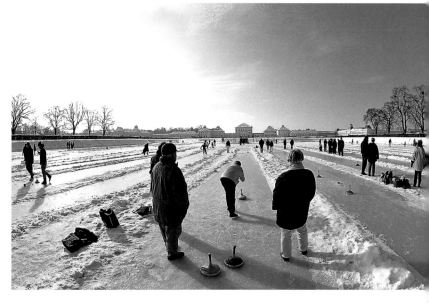

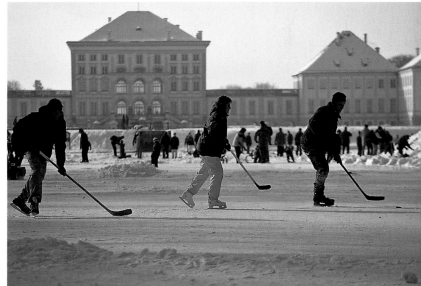

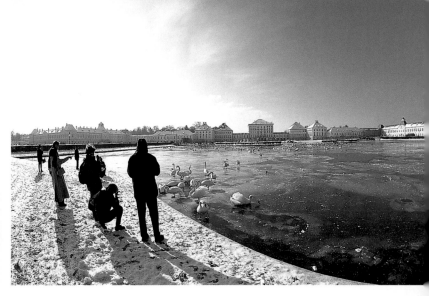

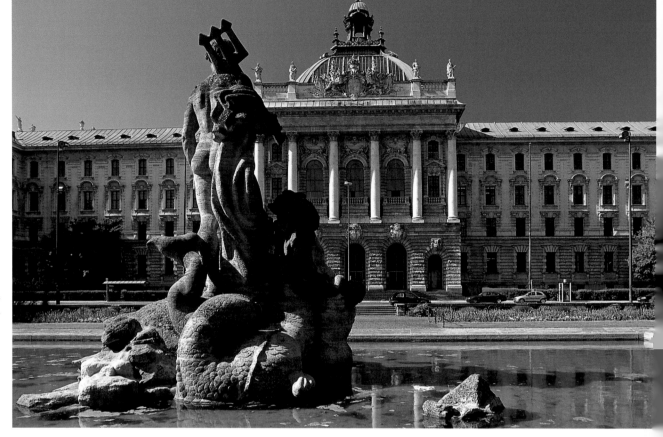

Just a stone's throw from the manic bustle of Stachus is a haven of peace and quiet: the old botanical gardens with the fountain of Neptune. In the background is the palace of justice built at the end of the 19th century.

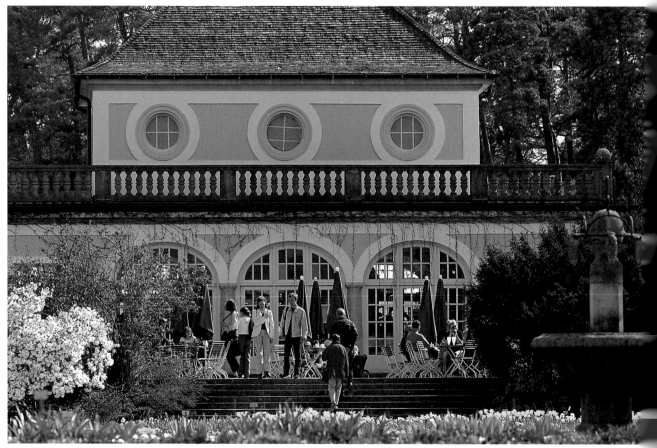

The new botanical gardens are on Menzinger Straße in Nymphenburg. Laid out in 1914, the 50 acres of park are a place of refuge for gardeners and nature-lovers all year round. The Schmuck-hof has a pleasant café.

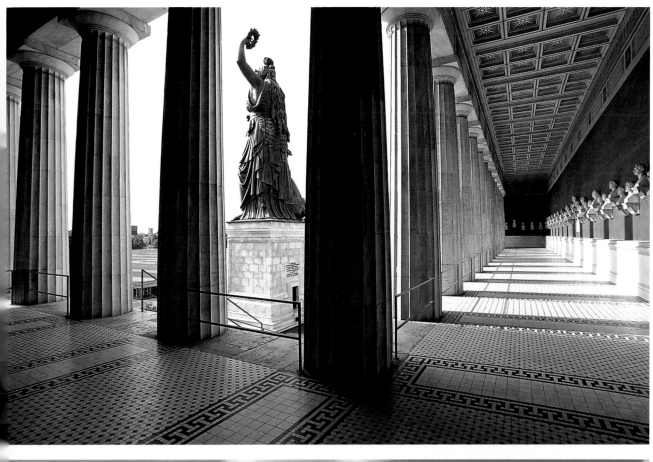

A statue of Bavaria by Ludwig Schwanthaler towers high up above the Theresienwiese. A product of the mid-19th century like the hall of fame next to her, Bavaria is the only woman to be honoured among the many busts of famous men.

Once a 15th-century hunting lodge, Schloss Blutenburg in Obermenzing now accommodates an international library for young people.

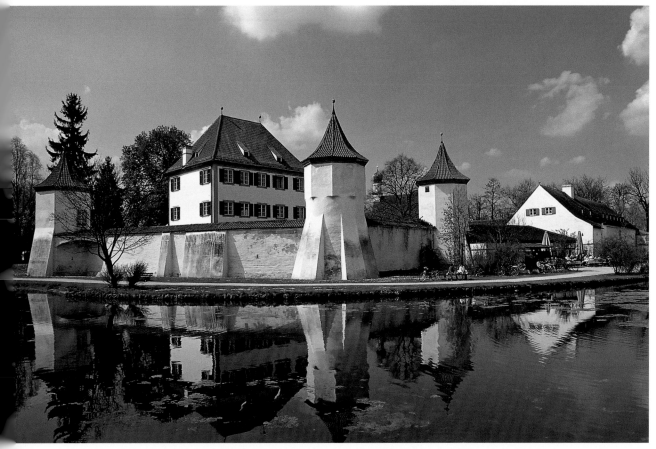

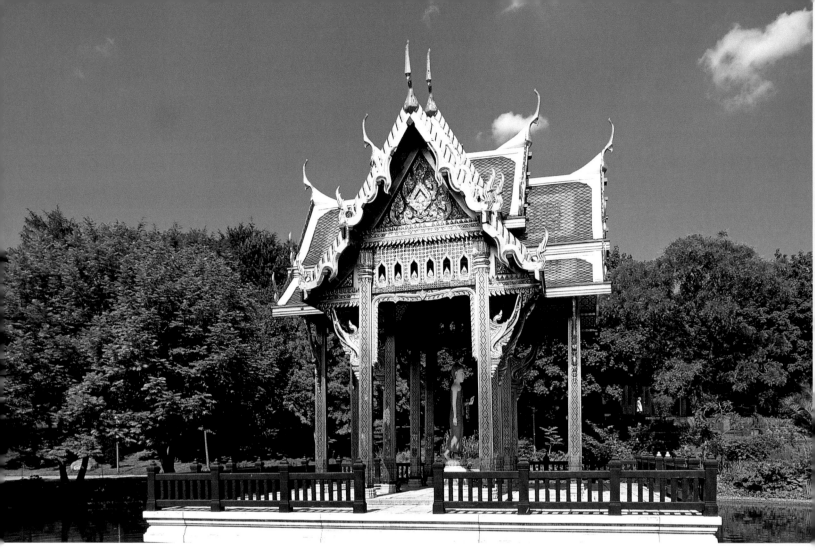

Above:
Westpark was set up especially for the international exhibition of gardening which took place in Munich in 1983. This Japanese pavilion has remained to commemorate the event.

Right:
Country idyll with church in Fröttmaning. A new football stadium is currently under development in this suburb of Munich, opening to host the World Cup in 2006.

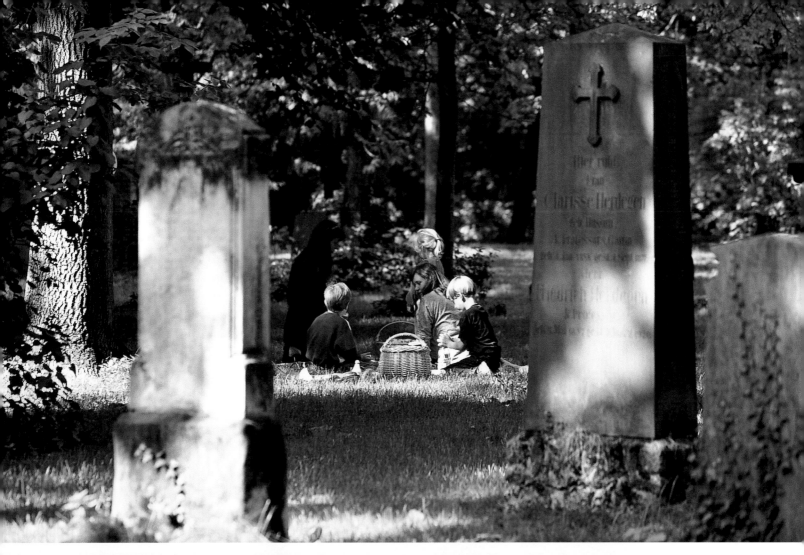

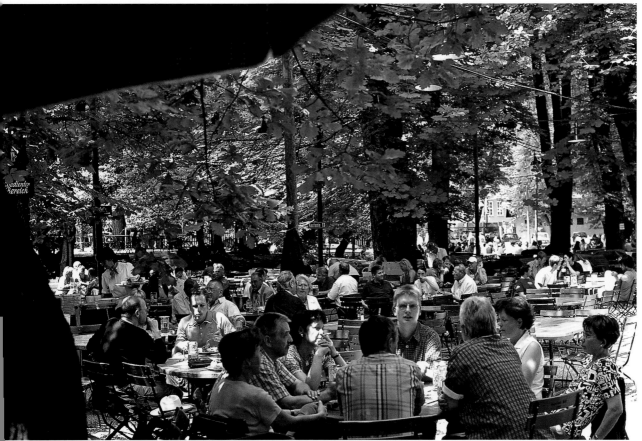

Above:
Where the dead come to
rest and the living find
peace: the old north
cemetery in Schwabing.

Left:
Augustinerkeller on
Arnulfstraße is one of
the better known water-
ing holes of Munich
which can count the rich
and famous among its
regular clientele.

103

Right:
However wild and wired the latest high-tech fad in funfair rides may be, you just can't beat the good old-fashioned merry-go-round.

Centre right:
One of the Oktoberfest traditions is Showmaster Schichtl, who in true fairground fashion invites hesitant spectators to roll up and step inside – here to watch an execution.

Far right:
The Oktoberfest is a great place to meet new people; lack of space means everyone has to squash up close together and join in the fun.

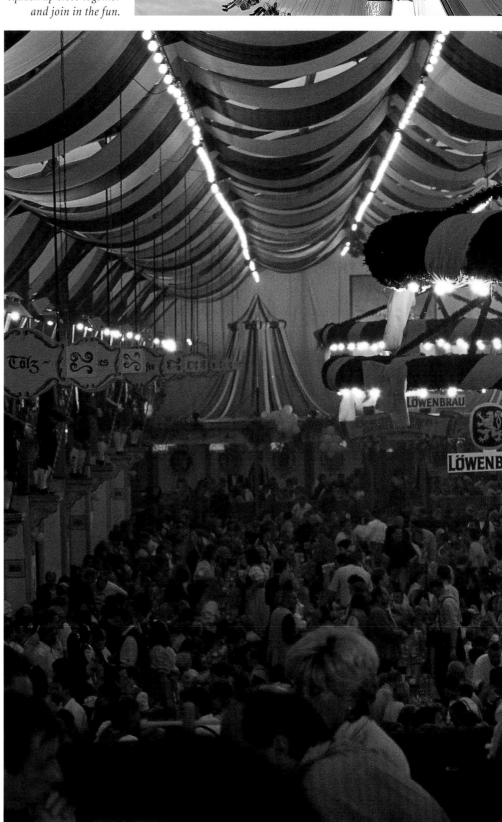

Above:
At the end of September / the beginning of October the people of Munich look to the heavens and pray for good weather. Going to the Oktoberfest in the rain just isn't as much fun ...

Right:
The decor may be different yet all of the beer tents at the Oktoberfest have several things in common: loud Bavarian oompah music, muscular waitresses brandishing fistfuls of beer and the smell of roast chicken and beer.

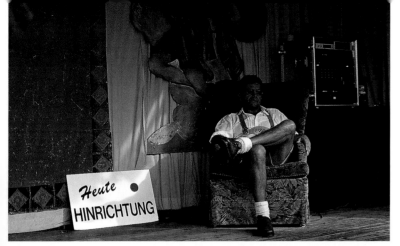

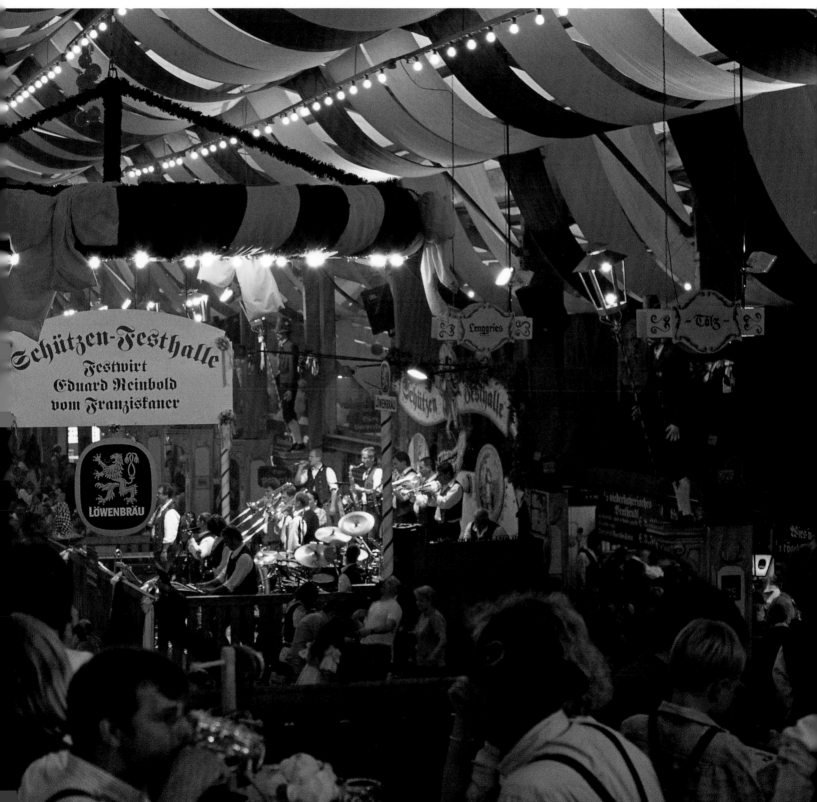

Below:
The Lutheran Church of St Lucas dominates the banks of the River Isar, shrouded in a blanket of snow. Its extremely active community is often the talk of the otherwise predominantly Catholic town.

Below:
Everyone visiting Munich should take the plunge at sometime during their stay – preferably here, at the restored Art Nouveau Müllersche Volksbad on Rosenheimerstraße, built at the turn of the 19th century.

Right:
The Gasteig arts centre has a magnificent concert hall which is home to the Munich Philharmonic and can seat up to 2,500.

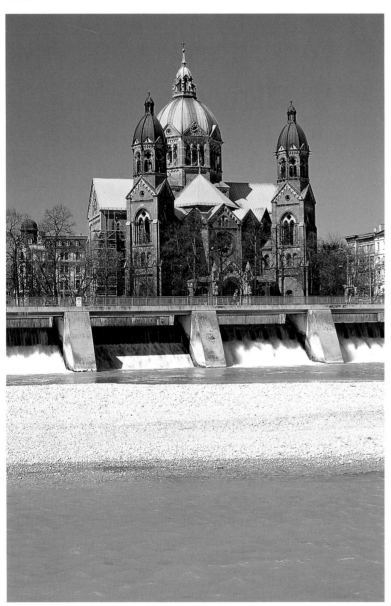

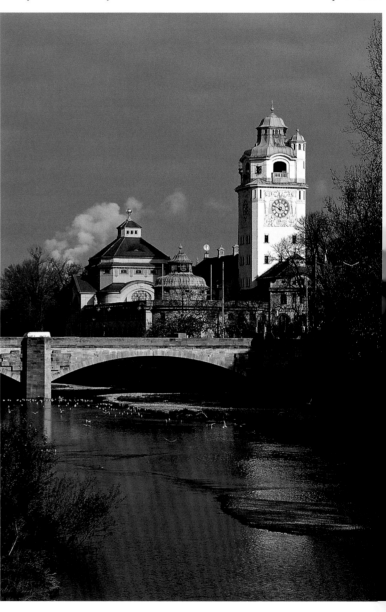

Right page, centre left:
The Gasteig has room for a theatre, an adult education centre and the city library. It's also the venue for Munich's book fair which takes place once a year early in the winter.

Right page, centre right:
Europe meets the River Isar: the European Patent Office, built between 1975 and 1980, seen from the Deutsches Museum.

Right page, bottom left:
In the second half of the 19th century King Max II had the Maximilianstraße built, with his Maximilianeum as its crowning glory, now the seat of Bavaria's state parliament.

Right page, bottom right:
In the hallowed halls of the palace of justice erected at the end of the 19th century near Stachu.

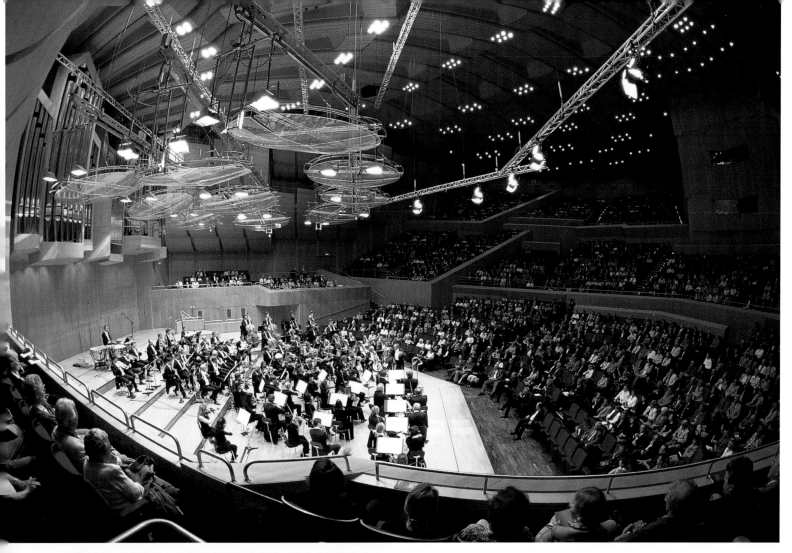

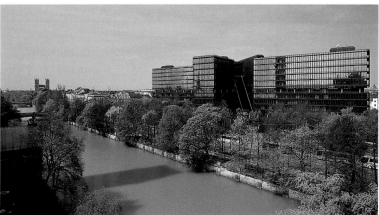

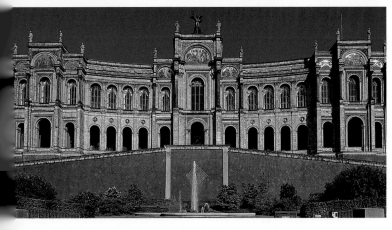

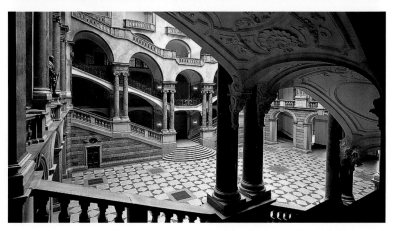

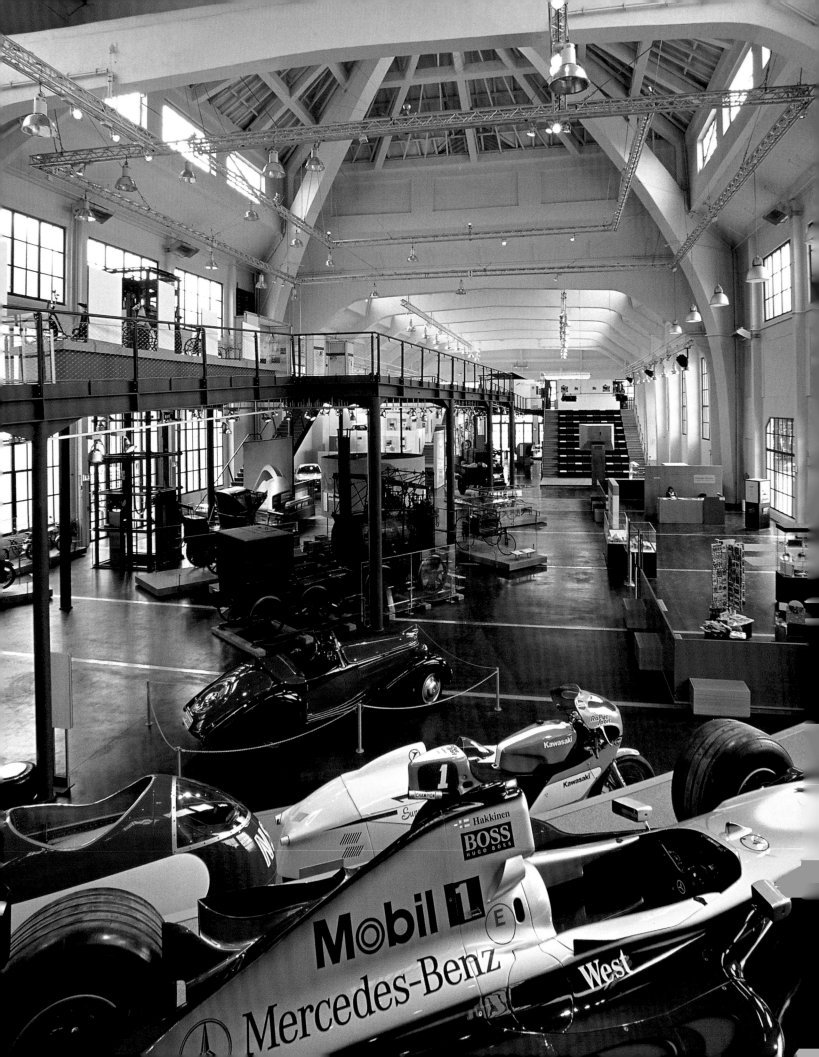

Left page:
Car, train and plane freaks should make a beeline for the recently opened museum on Theresienhöhe, a branch of the world-famous Deutsches Museum devoted to man and his means of transport.

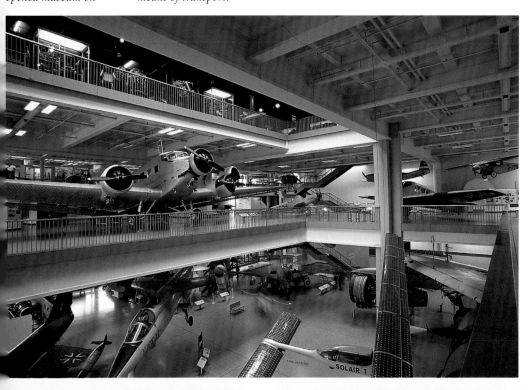

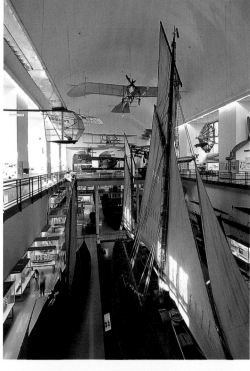

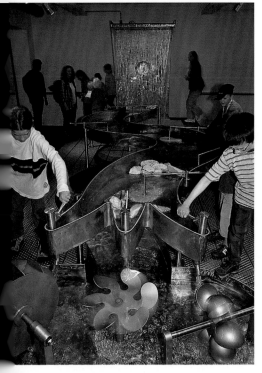

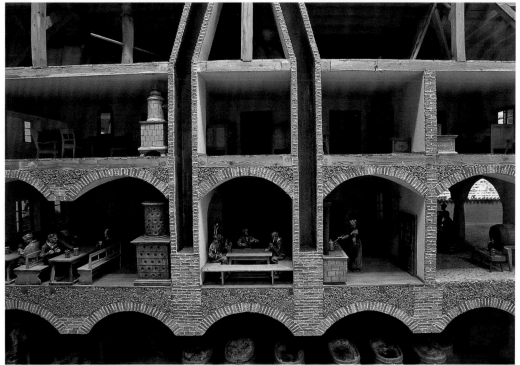

bove:
...iation, navigation, ...ewing, mining, ...draulic engineering, astronomy, et cetera, et cetera: the Deutsches Museum has everything scientific and technical you could possibly imagine – and more. It's one of the biggest museums of its kind in the world and at its founding a century ago was revolutionary in its educational bent. Then and now children (and adults) could and can learn through play, taking part in experiments, pressing buttons and turning wheels to make things work. An absolute must for all the family.

Below:
As far as modern archi-
tecture is concerned,
Munich as a whole is
lacking in enthusiasm.
One of its more success-
ful efforts, however, is
the Hypo-Vereinsbank
on Arabellastraße, one
of the more imaginative
products of the 1970s.

Below:
Places to live are in short
supply in Munich and
thus extremely expen-
sive. This could soon
change, with many new
estates springing up
around town, such as
here in Westend.

Right:
Munich's new inter-
national airport is about
30 kilometres/20 miles
northeast of the city centre
in Erdinger Moos. The
new exhibition grounds
and congress centre have
been built nearby, secur-
ing Munich's future as a
major business venue.

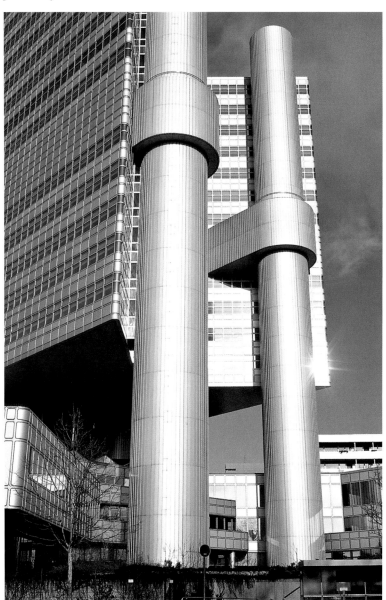

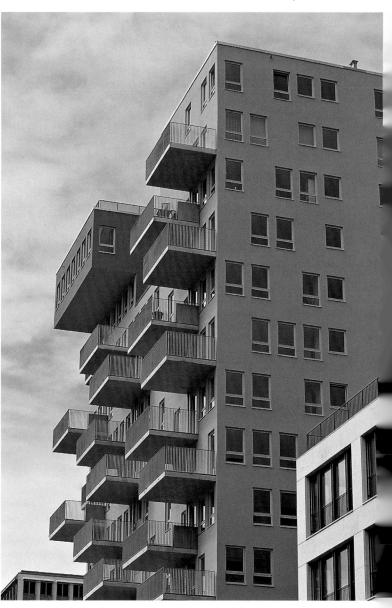

Right
Munich may have a l
of them, but not all of i
churches are baroqu
This one, Herz-Jes
Kirche in Neuhause
consecrated in 2002,
decidedly moder

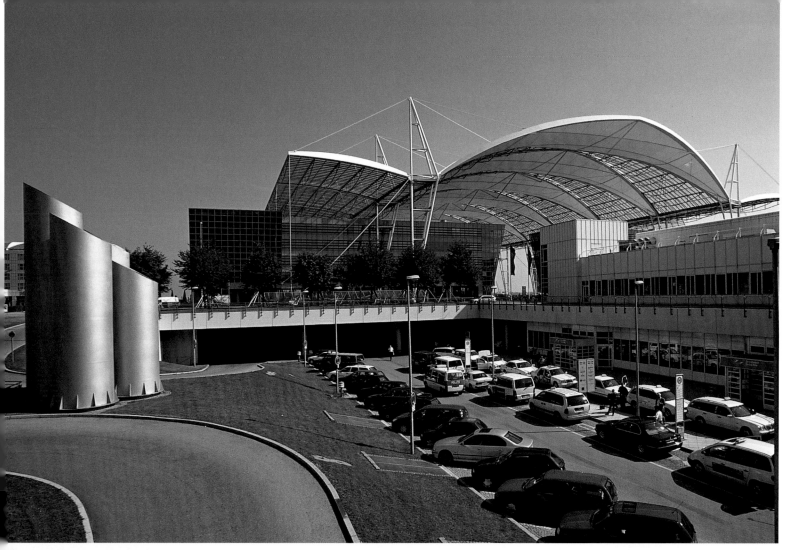

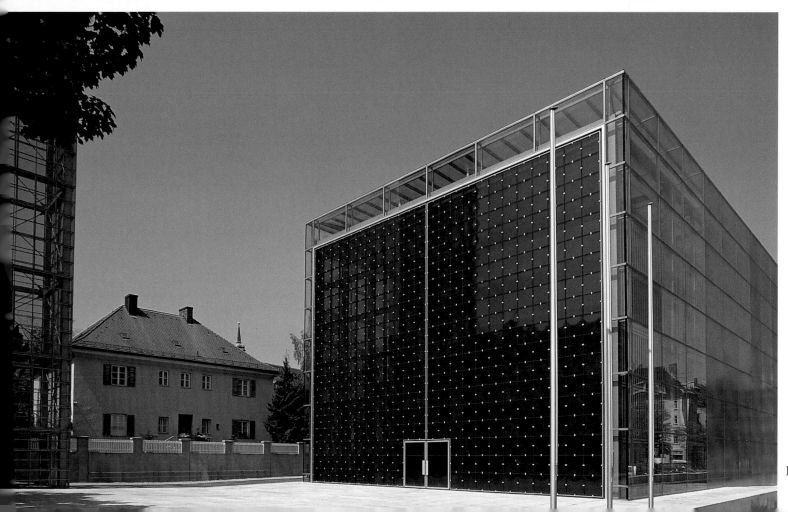

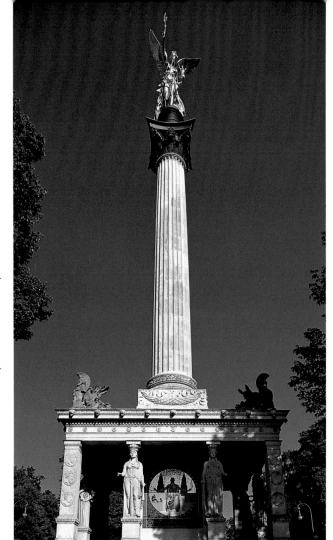

Right:

At the end of Maximilianstraße you have the magisterial Maximilianeum; the termination of the Prinzregentenstraße is illuminated by an angel of peace, completed in 1899.

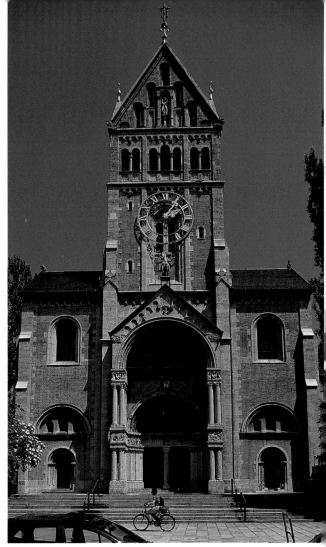

Far right:

The Parish Church of St Anna, depicted here, was built in the late 19th century; the monastic church opposite, also dedicated to St Anna, was the first Rococo place of worship in Munich.

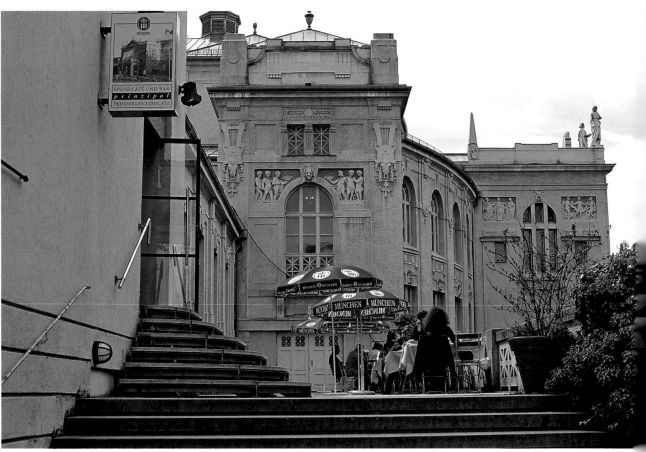

Right:

In 1988 the Prinzregententheater was finally restored to its former glory.

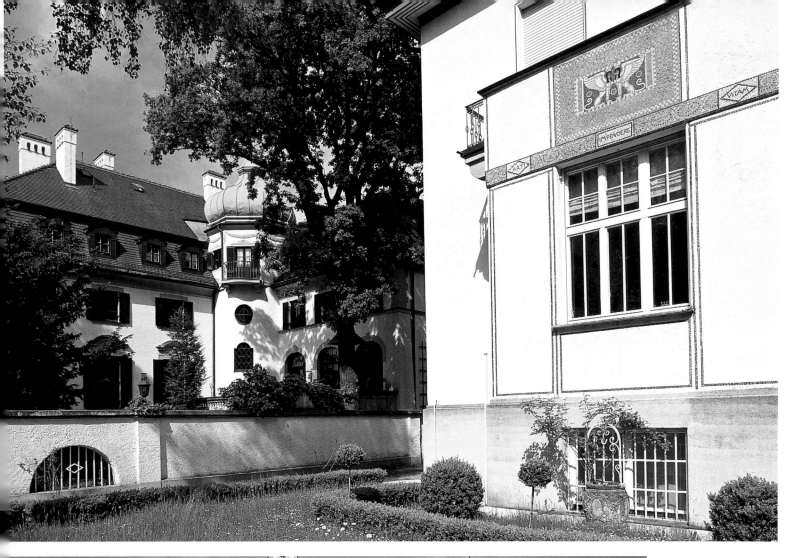

Above:
Bogenhausen is one magnificent villa after another; here numbers 22 and 23 on Maria-Theresia-Straße. To the left is the Hildebrand-haus from the end of the 19th century, once a popular meeting place for the creative minds of Munich. It now accommodates the Monacensia library, packed with information on the city of Munich.

Left:
Café Prinzipal in the Prinzregententheater which is full to bursting after the performance.

Tierpark Hellabrunn is a great place to go at any time of the year. It was one of the first zoos to exhibit its charges by continent and not species.

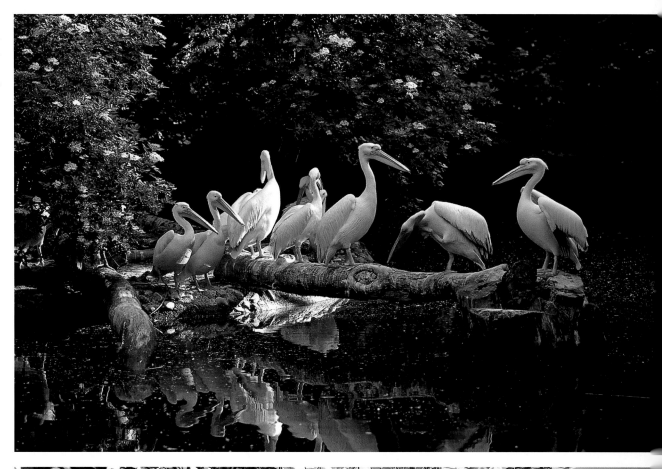

The animals have plenty of freedom at Hellabrunn and are kept as they would be in the wild – as far as this is possible in captivity. The reptiles even have their own reptile house.

Right page:
Opposite the aggressively contemporary Gasteig arts centre a tiny piece of village idyll has remained on Innere Wiener Straße. Here the church of St. Nikolai with the Altöttinger Kapelle.

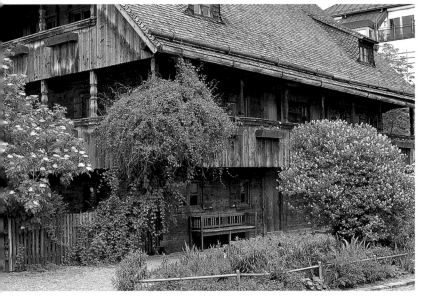

Top left:
*Green and cosy:
Weinhäusl on Wiener
Platz in the picturesque
suburb of Haidhausen.*

Centre left:
*Kriechbaumhof on
Preysingstraße is an
ancient Haidhausen inn
dating back 300 years.*

Bottom left:
*Erich Kästner came to
Munich from Dresden
after the last war. He is
buried at St Georg, the
peaceful little cemetery*

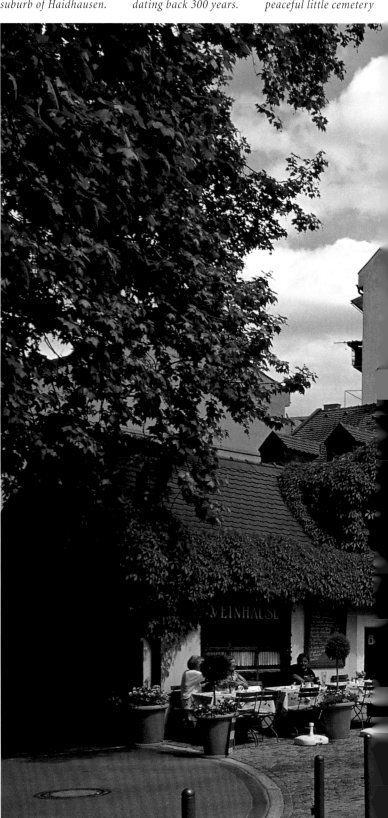

in Bogenhausen, where
he lies alongside other
names of renown such as
Oskar Maria Graf, Rainer
Werner Fassbinder and
Annette Kolb.

Below:
*Wiener Platz with its
maypole, tiny market
and huge beer garden
has become even more
idyllic since it was
pedestrianised in 2003.*

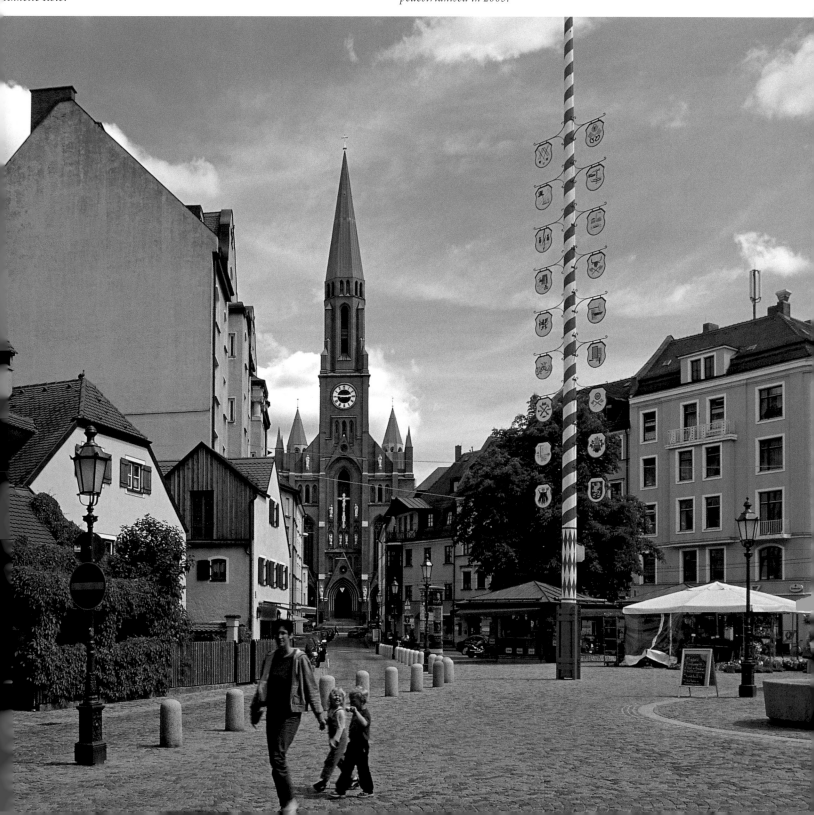

»Like a village between two hills Munich is entrapped between art and beer« wrote Heinrich Heine. This is still true today; after studying the cultural visitors to Munich should devote themselves to the culinary. Sitting in a beer garden in summer, for example, is an absolute must, chinking enormous glasses of beer with your friends while waiting for your fried or salted fish, pretzels and white sausages.

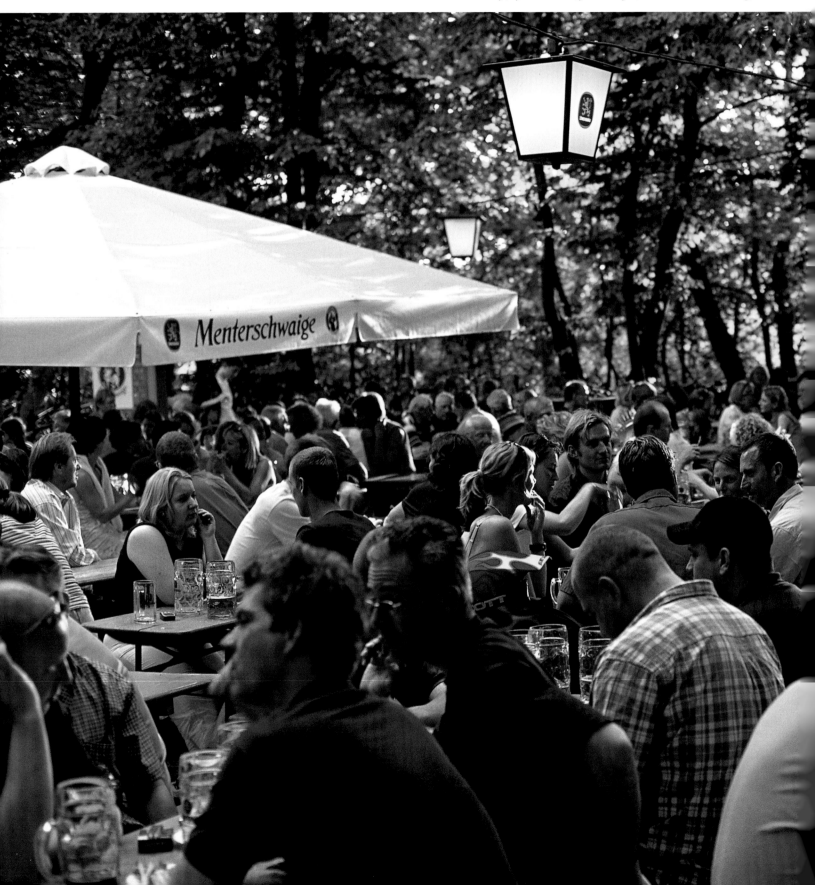

According to the locals, the latter should be eaten in the morning and »not hear the clock strike midday«. The custom goes back to the days before food preservatives were introduced but the people of Munich still observe it with due diligence.

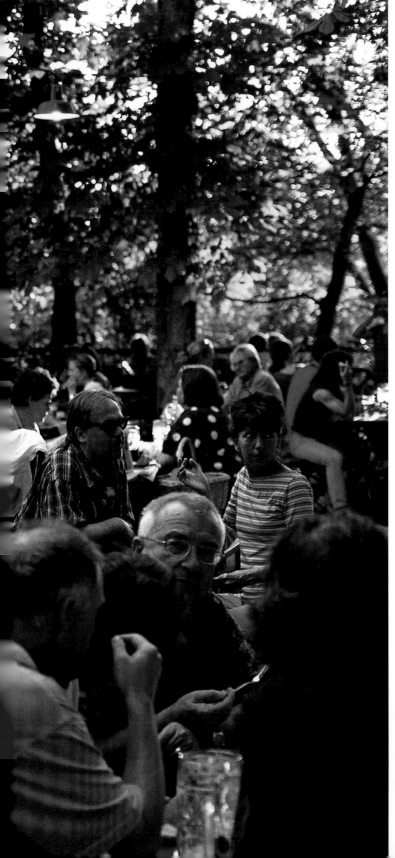

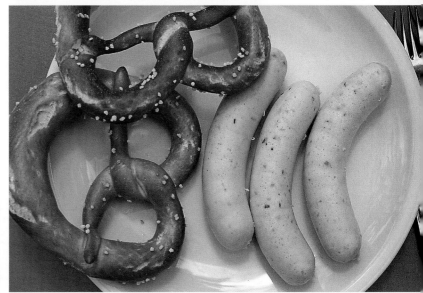

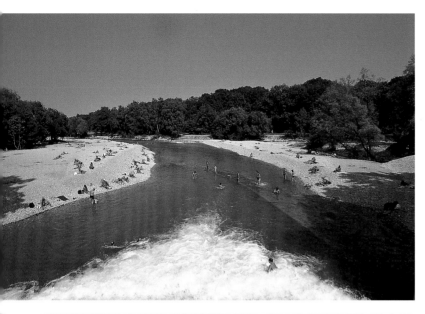

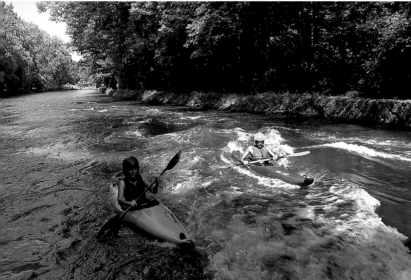

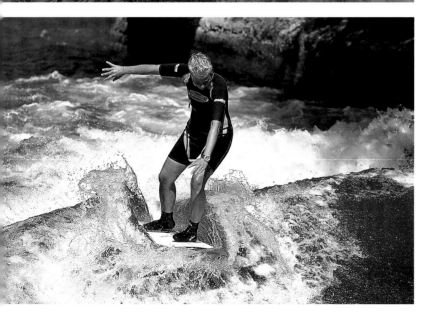

Top left:
Fun in the sun on the banks of the Isar. The water is extremely cold at all times of the year but the intrepid of Thalkirchen are not to be perturbed.

Centre and bottom left:
The Isar may not be navigable but is plenty deep enough for canoes. Thalkirchen in particular has good strong currents and even a few rapids for the more experienced to tackle.

120

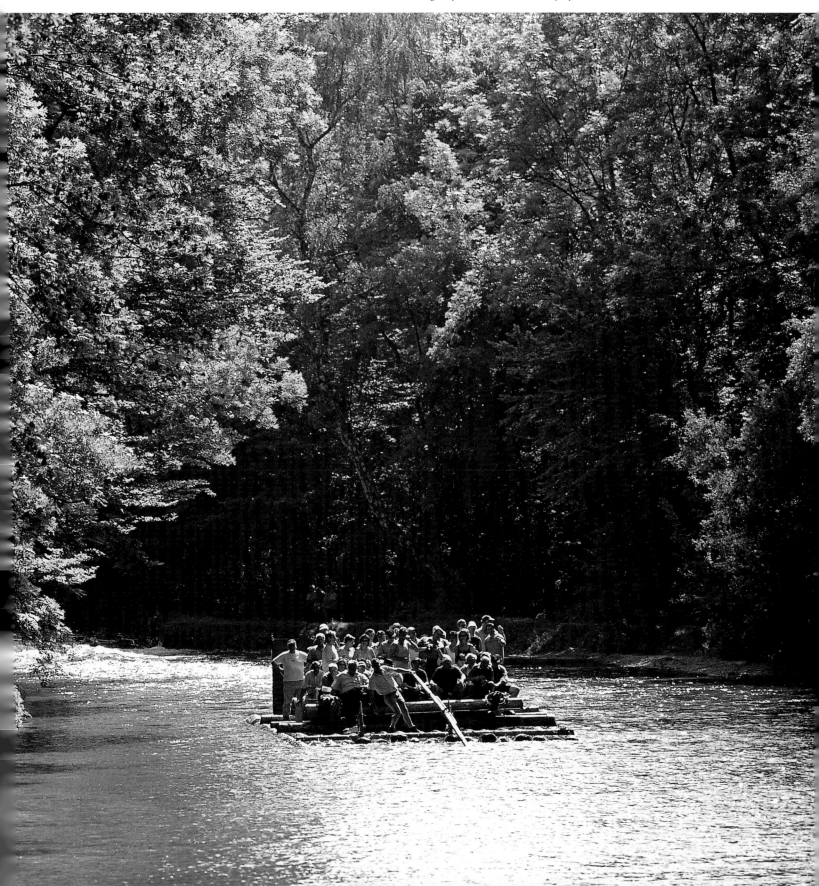

Below:
One of the big attractions of summer on the Isar is rafting. Where better to bond with your colleagues from work than aboard a float from Wolfratshausen to Thalkirchen, cruising down the river on a sunny afternoon.

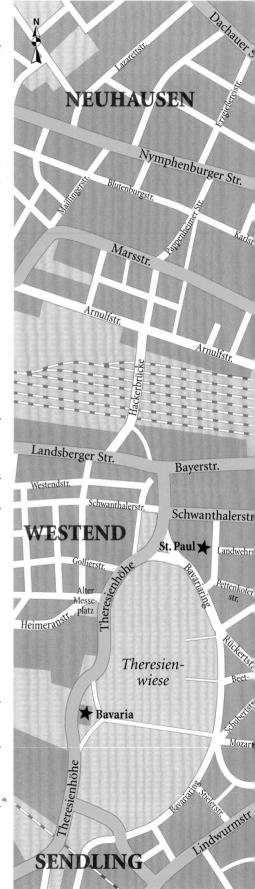

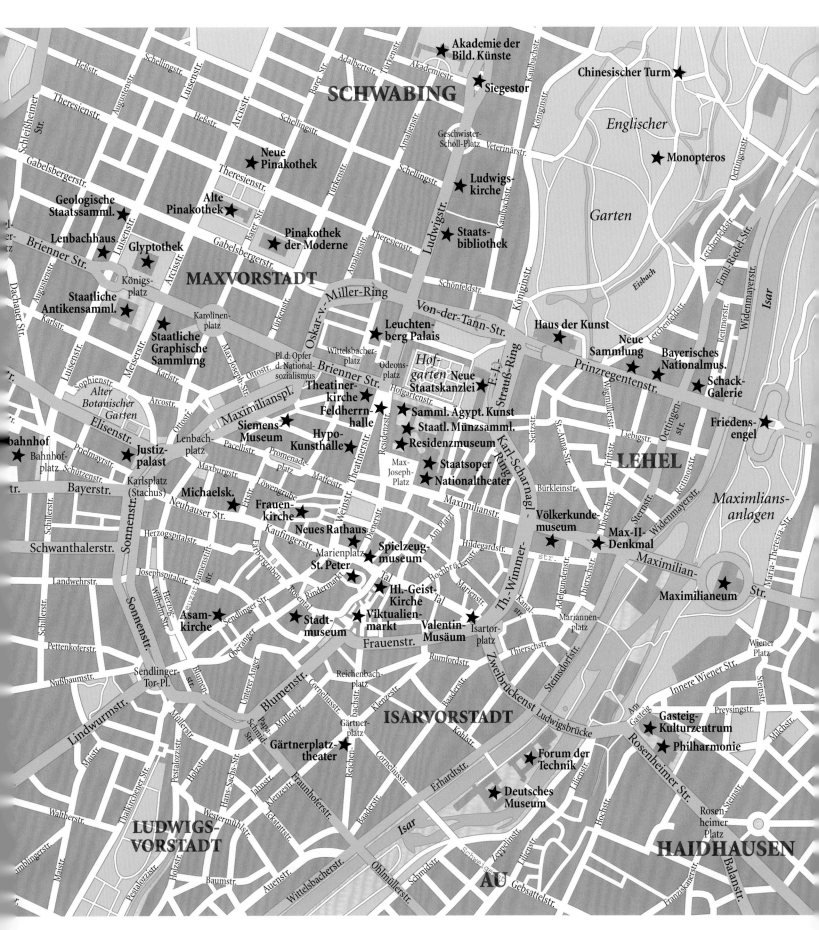

SCHWABING

Akademie der Bild. Künste

Chinesischer Turm

Siegestor

Englischer

Neue Pinakothek

Monopteros

Garten

Geologische Staatssamml.

Alte Pinakothek

Ludwigs-kirche

Lenbachhaus

Glyptothek

Pinakothek der Moderne

MAXVORSTADT

Staats-bibliothek

Staatliche Antikensamml.

Staatliche Graphische Sammlung

Oskar-v.-Miller-Ring

Von-der-Tann-Str.

Haus der Kunst

Neue Sammlung

Bayerisches Nationalmus.

Leuchten-berg Palais

Prinzregentenstr.

Schack-Galerie

Alter Botanischer Garten

Theatiner-kirche

Hof-garten

Neue Staatskanzlei

Friedens-engel

Feldherrn-halle

Samml. Ägypt. Kunst

bahnhof

Siemens Museum

Hypo-Kunsthalle

Staatl. Münzsamml.

Justiz-palast

Residenzmuseum

LEHEL

Bahnhof-platz

Staatsoper

Karlsplatz (Stachus)

Michaelsk.

Nationaltheater

Völkerkunde-museum

Maximlians-anlagen

Frauen-kirche

Max-II-Denkmal

Neues Rathaus

Spielzeug-museum

Maximilianeum

St. Peter

Marienplatz

Asam-kirche

Hl.-Geist-Kirche

Stadt-museum

Viktualien-markt

Valentin-Musäum

Gasteig-Kulturzentrum

Gärtnerplatz-theater

ISARVORSTADT

Philharmonie

Forum der Technik

LUDWIGS-VORSTADT

Deutsches Museum

HAIDHAUSEN

AU

With or without the Oktoberfest Munich is beer, with names like Augustiner, Hofbräu, Löwenbräu and Paulaner famous all over Germany.

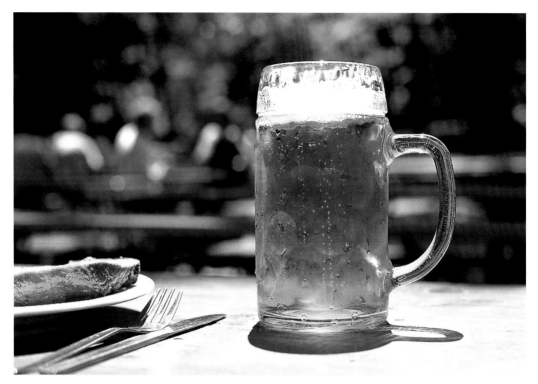

Credits

Design
hoyerdesign grafik gmbh, Freiburg

Map
Fischer Kartografie, Fürstenfeldbruck

Translation
Ruth Chitty, Schweppenhausen

Printed in Germany
Repro by Artilitho, Trento, Italy
Printed/Bound by Offizin Andersen Nexö, Leipzig
© 2005 Verlagshaus Würzburg GmbH & Co. KG
© Photos: Martin Siepmann

ISBN 3-8003-1622-6

Martin Siepmann,
born in 1962, is a freelance photographer and writer. He has had numerous illustrated books published on regional and international travel; his photographs have also appeared in calendars and travel reports. Much of his work focuses on Bavaria and Munich.

Christine Metzger,
born in Miesbach in Upper Bavaria in 1953, lives and works as a freelance travel writer in Munich. Besides having articles published in daily newspapers, travel magazines and on the radio she has also written many illustrated books and travel guides.

Stürtz

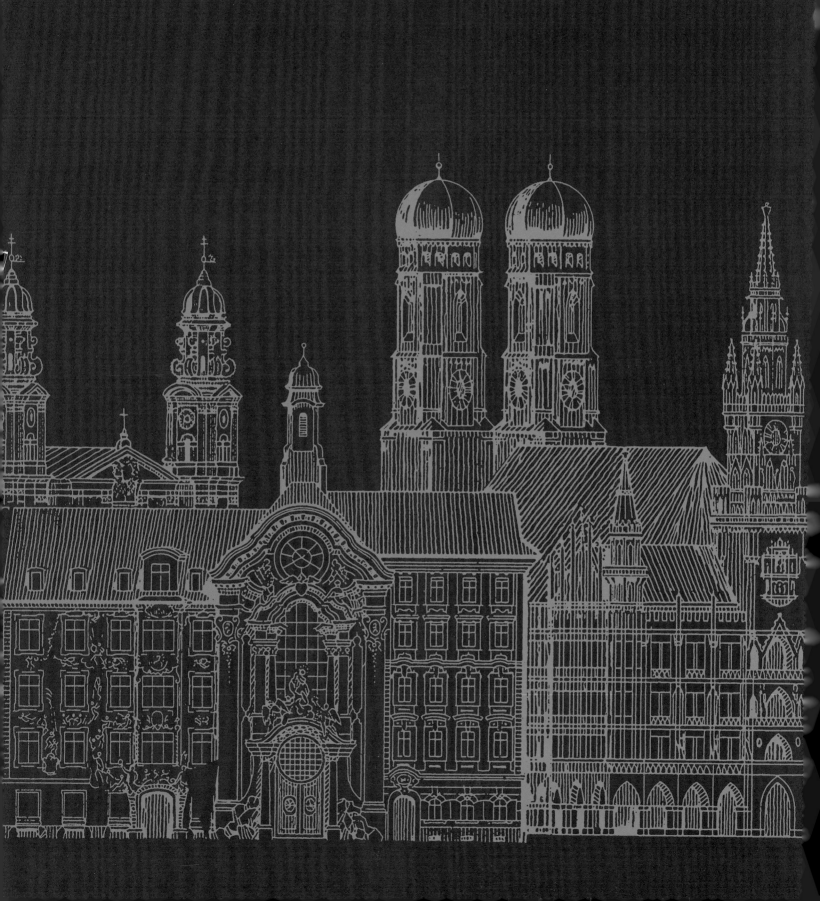